D1376495

THE LITERATURE OF PHOTOGRAPHY

THE LITERATURE OF PHOTOGRAPHY

Advisory Editors:

PETER C. BUNNELL
PRINCETON UNIVERSITY

ROBERT A. SOBIESZEK
INTERNATIONAL MUSEUM OF PHOTOGRAPHY
AT GEORGE EASTMAN HOUSE

PICTURE-MAKING

BY

PHOTOGRAPHY

BY

H. P. ROBINSON

ARNO PRESS
A NEW YORK TIMES COMPANY
NEW YORK ★ 1973

Reprint Edition 1973 by Arno Press Inc.

Reprinted from a copy in
 The George Eastman House Library

The Literature of Photography
ISBN for complete set: 0-405-04889-0
See last pages of this volume for titles.

Manufactured in the United States of America

———◆———

Library of Congress Cataloging in Publication Data

Robinson, Henry Peach, 1830-1901.
 Picture-making by photography.

 (The Literature of photography)
 Reprint of the 5th ed., published in 1897.
 1. Photography, Artistic. I. Title. II. Series.
TR642.R62 1973 770'.28 72-9230
ISBN 0-405-04936-6

PICTURE-MAKING

BY

PHOTOGRAPHY

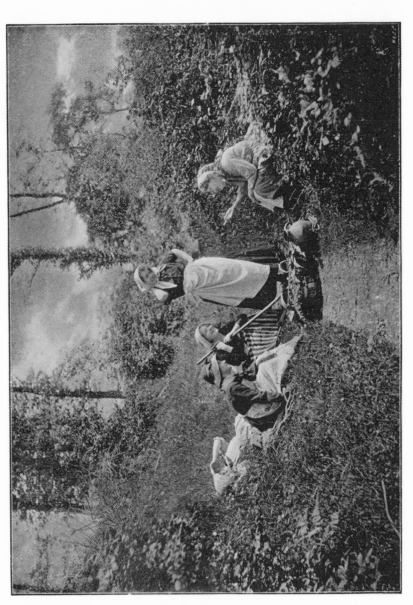

A MERRY TALE.

PICTURE-MAKING

BY

PHOTOGRAPHY.

BY

H. P. ROBINSON,

AUTHOR OF

"PICTORIAL EFFECT IN PHOTOGRAPHY," "THE STUDIO, AND WHAT TO DO IN IT,"
"LETTERS ON LANDSCAPE PHOTOGRAPHY," ETC. ETC.

FIFTH EDITION.

LONDON:

HAZELL, WATSON, & VINEY, Ld.,

1, CREED LANE, LUDGATE HILL.

—

1897.

PRINTED BY
HAZELL, WATSON, AND VINEY, LD.,
LONDON AND AYLESBURY.

PREFACE.

IT has been said of Gibbon, the historian, that he did not always sufficiently distinguish between his own personality and that of the Roman Empire. I am afraid that the following chapters may be open to a similar objection. I fear that a great deal more will be found concerning my own personality and productions than a modest writer would willingly admit; but this cannot easily be avoided. The nature of the information to be conveyed, and the lessons to be inculcated, demand that I should teach the results of my own experience, and suggest that the pictures which have been the outcome of that experience would be the most suitable illustrations. It will be evident that pictures which have been actually produced by photography will better show the peculiarities and limitations of the art than any other method of illustration.

That photography should be not only the recorder of bald, prosaic fact, but also the means by which something akin to imagination or fancy—real live art—may be worthily embodied, has been the one aspiration of my life. To this end, my aim has been, in the following chapters,

to induce photographers to think for themselves as artists, and to learn to express their artistic thoughts in the grammar of art. It is not the fault of the art of photography itself that more original pictures, exhibiting many of the qualities shown in other arts, are not produced. The materials used by photographers differ only in degree from those employed by the painter and sculptor.

The illustrations, with the exception of one or two, owe their existence to photography. Without the help of the processes by which substitutes for woodcuts can be quickly and cheaply made from pen-and-ink sketches, a book of this kind could not be so effectively illustrated. They make no pretension to be refined examples, and their purpose will be served if they make more clear the words I have written.

I have great pleasure in acknowledging my indebtedness to Mr. Henry Blackburn—who, in his well-known and highly appreciated Exhibition Catalogues, was one of the first to use the photo-etching processes extensively—for permission to use some of the blocks from his admirable illustrated catalogue of the National Gallery, a book that should be in the hands of every photographer who desires to improve his knowledge of art.

CONTENTS.

The best in this kind are but shadows: and the worst are no worse, if Imagination amend them. — *Shakespeare.*

PICTURE-MAKING BY PHOTOGRAPHY.

CHAPTER I.

GELATINE PLATES AND THEIR USES.

THAT this little book on "Picture-Making" is not a treatise on chemistry, ought to go without saying; yet it is so much the custom, in books intended to teach the art, to make photographic pictures a matter of scales and weights, molecules and atoms, achromatism and astigmation, that it seems necessary to state that art begins where chemistry and optics leave off, and that there will not be one word of technicality, except where it is necessary for the elucidation of pictorial effect, in this book. Cameras and processes are but the material or mechanical appliances of the art, its pencils and pigments, its paper, panels, or canvas; as such they will be referred to; but to go into the matter of manufacture of materials would be quite foreign to my purpose.

Why should it be necessary in these days of dry plates for the photographer to prepare his own materials? It makes him no more an artist than it would add to the reputation of a Royal Academician if he ground his own paints. It is probable, indeed, that the work of both painter and photographer would suffer if they made their own colours, brushes,

1

plates, and lenses. It is not easy to suppose that either of them could command the experience or plant of the manufacturer. There was a time when neither painter nor photographer could obtain materials fit to work with if they did not prepare them themselves; but in the case of the painter that difficulty was removed many years ago, and for the photographer it disappeared when all other methods of taking a negative died, almost a sudden death, at the birth of a gelatine process. Just as there are those who take a delight in cooking their own dinner, there are some who still enjoy making their own dry plates; but with most persons the cooking would take away the appetite and spoil the dinner; so would the plate-making dry up the energy to use them properly.

It would certainly be well for the student to read up the subject, and gain some acquaintance with the make and meaning of the lenses, cameras, and chemicals he uses; but, so far as plates are concerned, a theoretical knowledge should be sufficient. Of course he must know how to use the materials supplied to him, how to employ wisely all those almost endless delicacies of manipulation that go to the production of a modern negative, and should have a comprehensive knowledge of all that can be done in the way of printing, but he need not make his plates or albumenize his paper. Nevertheless, he should be able to decide for himself whether he should use albumenized paper at all, or should employ one of the more artistic means of completing the picture. Again there comes in the analogy with the painter. It is proper for both artists to know something of the history of their art, and of the tools they employ; but for practical work the photographer need no more make his own plates or developer than his lens or camera. My advice, then, is, buy your materials of those whose business it is to supply them, and confine your attention to the study of how to use them. But

whether you make your own plates or buy them, I shall assume that you know how to make them into good technical negatives. That is all I ask of you at present. It is my purpose to help you to make good pictures as near to works of art as our processes will allow.

It has been the fashion with writers on photography to apply the term, " A new power," to nearly every invention or suggestion made in connection with the art. This honourable title has sometimes been deserved, oftener not ; but it cannot be denied that, taking one advantage only, the rapidity of exposure allowed by the gelatine plate confers a distinct and very real power on photographers which they did not enjoy previous to its introduction. The discovery enables them to produce, on the one hand, quite new effects ; on the other gives them the means of securing old effects with greater ease and certainty, and renders what was once a dirty toil into a charming pastime, as well as a serious study.

The process being much quicker than any hitherto discovered, is admirably adapted to all subjects which require, or will admit of, a very short exposure ; those, for instance, taking that fraction of a second which it is usual, but not quite correct, to call instantaneous. This quality alone of course opens up a vast mine of subjects that have hitherto been only feebly attempted. Still, it has its disadvantages also. Instantaneous pictures, of a sort, have become so easy of accomplishment, that our exhibitions are flooded with them. These photographs may be very useful to painters, because they are real bits from nature, real machine views, at least ; but they are not art. Yet if you look through an acre of them, you will find every now and then you will come upon a gem. Put these selected gems aside as you find them, and after you have been through the collection, turn your attention again to the few selected prints. You will be astonished to find that, although the scores of sea views were all so apparently alike, they

appeared to be all done by the same photographer; by some happy accident the selected few were better than the others; that the best pictures were owned by one or two, or at most three, good names, and that you had selected all their works which had been mixed up with the rest of the collection. This would, I think, conclusively prove that even in such subjects as apparently refuse to allow the photographer to have any control over them, the artist photographer will compel circumstances, and make his art-knowledge felt even in an instantaneous shot at a passing effect in nature. The little gems produced in this way are not usually the result of haphazard chance, but of months of careful waiting; and nothing is accepted as good enough by a true artist in the way of a subject, but those arrangements of sea and sky which lend themselves to pictorial effect by forming themselves so that they should agree with the laws of composition and chiaroscuro, or have a beauty of their own apart from compliance with rules. Nothing but a sound knowledge of those laws, and constant practice, will enable a photographer to make the immediate and lightning-like application of them which is necessary in instantaneous photography. In photographing scenes containing groups of figures the best artists will get the best pictures. A photographer without a knowledge of art would simply "fire into the brown of them," as a sportsman would say, and trust to luck; while a photographer who knew something of the rules of composition would wait until his figures arranged themselves to advantage, and would know when was the best moment to pull the trigger of his camera.

Soon after the new plates came into use, there arose a controversy as to whether the new system would ever take the place of the wet process in simple landscape. It was thought the negatives would not give the peculiar crispness and sparkle, combined with sharpness, which had been a characteristic

of the old process. And at the time there appeared to be sufficient reason for this doubt. But since then, it has been triumphantly shown, in thousands of landscape photographs, that it not only could give all the old effects, but added new charms when skilfully employed. There is more of what artists call " quality " in a good gelatine negative than in one on a collodion plate, and the freedom from the worries incident to a wet process gives the photographer more opportunity of looking at the æsthetic side of his art, and ought besides to prolong his life. The new system has its difficulties; but pinholes, lines in the direction of the dip, dirty plates and their effects, fogging, drying of the film, oyster-shell markings, dirty fingers and spoiled clothes, and many other worries, are gone.

Besides these advantages, the photographer has now the opportunity of making his landscapes into veritable pictures by the addition of figures. This we all know was possible with the old process, but the loss occasioned by the moving of the figures owing to the long exposure was serious, and there was very little chance of getting the spontaneous effect in the figures we now see in so many landscapes; while to introduce an animal, a cow, horse, donkey, or dog was to attempt a forlorn hope. We have thus open to us new subjects. Animals, and incidents of rustic life, afford a wide range of subjects now suitable for our art that previously could not be attempted. It is true we have always had portraits of animals; but they have nearly always been portraits of individuals brought up for the purpose of having their likeness taken—the prize bull, the favourite horse, or the pet dog. We can now visit the animals at home, and make pictures of them while pursuing their ordinary avocations, such as cattle in a farmyard or cooling themselves in a stream during the noonday heat, horses ploughing, pigs feeding, deer in a park, and—what has not yet been done

quite successfully, but which is possible—pigeons flying, or just alighting to be fed. Yet of the many instantaneous photographs now taken few have any pictorial interest, and many are absolutely untrue to nature as we see it. I shall have a separate chapter on this subject further on.

It is now so easy to catch what might be called the accidental beauties of nature. Hitherto, before the tent could be erected and the plate prepared, the cloud that partly covered the landscape, and gave a beautiful breadth of light and shade, was gone; the figures that gave point and life to the view had moved on, or the waggoner with that picturesque waggon and team of powerful horses could not wait.

But perhaps the purpose for which quick dry plates are found of as much advantage as anything else is in photographing interiors. There were many places where the wet plate with its rain of silver drops was tabooed. Museums and picture-galleries, well-furnished houses and yachts, are now open to the camera, while as for quality, the results have never before been approached.

In professional portraiture it is every photographer's experience that he used to lose a certain percentage of sitters because he could not take them quickly enough, even on fine days, by the old process. Young children, nervous people, and occasionally some who are afflicted with diseases, such as palsy, which prevent them sitting the necessary time, were usually the causes of these vexatious losses. This percentage is now, by aid of the quick plates, either very much reduced, or wiped out altogether. Subjects that at one time I should have looked upon with despair, I now anticipate with pleasure. Subjects that were once almost out of the question are now possible, and the merely possible of the old time are now easy. Very little more is now required than a knowledge of what will make a picture, and a capacity—rarer than some

people would think—for making up your mind. That the photographer may acquire the faculty of making up his mind, and that he may know that it is made up rightly, is one of the objects for which this book is written.

Although I do not mean to interfere with the teachers of technical photography, there is one point in connection with dry plates I cannot refrain from giving; it is this:— Do not make experiments in the field; you will have enough to do to make pictures. Some photographers will have a different kind of plate, of varying degrees of sensitiveness, in each slide. This is scientific experiment, if you like, but not picture-making. Find out by trial at home a make of plate that you think will suit you, and keep to it. It is easier to get good pictures with rather inferior plates, *if you know them*, than with first-rate ones of which you have no experience. I will not go as far as to say don't try to get a better kind of plate than those you are using—that would be to stop all progress—but do not change for the sake of change.

CHAPTER II.

OUR TOOLS.

THE introduction of dry plates has revolutionized photography in more ways than one. The immense increase in rapidity has rendered many of the quick-acting lenses—triumphs of the optician's art—almost useless, and in time those prodigious efforts of the camera-maker's genius and French polish, in which some photographers delight, will be looked upon as curiosities, or burnt as lumber. It will be found that the camera of the future will run more to lightness and adaptability. I have always protested against the weight some manufacturers have imposed on the unfortunate carriers of their cameras, and am pleased to see them working in the right direction at last. There was a time when it was impossible for photographers to get a camera made to their liking, except by the village carpenter. The despotic manufacturer who never used a camera in his life, insisted that he knew better what a photographer wanted than he did himself, and the unfortunate operator had to submit. Many years ago, a famous African traveller asked me to inspect a photographic outfit which had been prepared for him by order of the Government. What he really required, in my opinion, was about thirty pounds weight of apparatus and materials, neatly packed in a small box, or, to be liberal, say another ten pounds for glass—cost : not more than forty or fifty pounds. It was not necessary that the photographs

should be of a large size; and with an outfit similar to this, any intelligent photographer, other circumstances agreeing, ought to be able to give a pretty good idea of a journey through Africa. What really was provided was contained in several enormous cases weighing nearly a ton, and which cost several hundreds of pounds. Amongst other absurdities I found that the collection contained three pounds of ammonia (at that time occasionally employed for correcting the nitrate bath, and of which a few drops would have been sufficient), and only one pound of hypo, notwithstanding that there was a ream of albumenized paper supplied! I said to the travel‐ ler's brother, who was to have been the photographer of the expedition, "You had better leave this little lot at home, and save yourself the trouble of dropping it into the first jungle you come to." The expedition sailed a day or two afterwards, and there was no time to make any material alteration. This grand set of Spanish mahogany, French polished, brass-bound for hot climates, etc., apparatus, with the accompanying laboratory of every chemical, liquid or solid, that the wildest scientific imagination could suggest as possibly useful in the art, never came back, nor was a single picture ever sent home.

Apparatus should be, above all things, light and easily worked; and at the same time there can be no objection to its being cheap; but I do not insist upon this, and low-priced articles are seldom cheap. It is, perhaps, more economical to obtain perfectly efficient tools at once than to begin with "cheap sets." These "sets" are useful in inducing people to begin photography, but they are soon discarded for something better. It looks so wise and inexpensive to get everything complete for fifty shillings, and all photographers know how difficult it is to give up the art, or to stand still, when they have once begun. The constant fascination photography exercises over its votaries is one of the curiosities of the

century; it is the only thing that has not gone out of
fashion during the last fifty years.

The apparatus for the traveller, to which I have alluded,
was for outdoor work. The arrangements for studio work
were still more complicated and clumsy. Let us visit, by way
of illustration, an enthusiastic amateur friend whose studio
is fitted up with all the luxuries in the way of apparatus
that wealth can supply. I find myself about to take a card
portrait. I focus the first half of the plate for a full-length
figure. Here I meet with a difficulty at the outset : ingenuity
has devised a snare, into which I immediately fall. Attached
to the lens is a cone, intended to prevent unnecessary rays of
light entering the camera, and fogging the plate (a difficulty
I never met with, under any circumstances, at home); inside
this conical shade is a shutter for exposure, worked from the
outside by a brass knob (this knob being round, your only
means of knowing whether the shutter is up or down is by
looking inside from the front); the shutter is hinged from the
top, and, when opened, is caught by a spring; to make the
spring hold, you have to give the shutter a jerk as you expose
the picture, which makes the camera vibrate. When I am in
the act of focussing, down comes the shutter. This is set up
again with greater care, and the slide inserted. The sitter,
who is the only one in the room who has an opportunity of
seeing or knowing, except from memory, discovers, just in
time, that the shutter is open, for with these cones, as I have
explained, the operator can only tell if the lens is open by
looking in at the front; the round knob gives him no indica-
tion. Before the intended exposure is quite over, the spring
gives way again, and the shutter falls. If these cones must
be used, the shutter should be hinged at the bottom, so that,
when open, it might fall ; there would then be no danger of a
premature and fatal termination to the exposure ; and if the
shutter was allowed, when shut, to incline towards the lens,

there would be no necessity for a spring, and, consequently, no danger of vibrations.

The card picture was followed by an attempt to take a life-sized head on a twenty by sixteen plate. It took two strong men and a guide to haul forth the large camera on rollers. This camera and stand is the masterpiece of its maker. The back has more ingenious movements than I could ever learn the use of, although I have given up my mind to finding out all the dodges; the front is a complicated system of brass and woodwork; the sides are panelled; the stand is made of heavy oak; it rises up and goes down, it tips forward and backward, and looks to the right and to the left. The sitter is placed, and we attempt to focus him—but now comes a difficulty. This camera, made by one of the first makers in the world, especially for taking life-sized heads, with all its complicated motions, has none whatever for meeting the requirement for which it was made. The focus is obtained by a screw by which the front of the camera, carrying the lens, is pushed in and out; not a bad form for small cameras, but any one who has tried to focus an object of the full size with an arrangement of this kind will know that it is impossible to do so. An image of the size of the original is produced by the lens being equi-distant from the object and the ground glass, and when the lens is made to move between the object and the plate, no focus can be got. The only way to get focus under these circumstances is to move either the camera or the sitter, both troublesome operations, especially when the camera is too heavy to move, and the sitter so well posed that any alteration may be for the worse. At length a make-shift sort of image is got, not exactly of the size required, but we are too exhausted to try further. The plate is put in the slide, which, being so heavy, is with difficulty placed in the camera, and then—something gives way somewhere, for the front of the camera falls a few inches. It is found that one of the blocks

of wood, which had been inserted to stop vibration, has fallen
out; for it is a peculiarity with these heavy stands, theore-
tically made to be very rigid, that they, from their many
complications, vibrate more than commoner and simpler ones.
The picture is at last exposed. The developing is a difficulty,
for the violent struggle with the camera has exhausted me,
and made my hand shake. The sitter, also, has become very
tired, and looks stupid. The end is, the negative is destroyed,
and none of us has pluck enough to try another. Thus
superfine apparatus may defeat the best intentions.

This is a faithful relation of a scene that occurred some years
ago. The apparatus is now rotting in an out-house. I have
shown what apparatus should not be; let us now try to arrive
at what it should be; and I have great pleasure in noticing
that a vast improvement has taken place in the designs of
cameras and other apparatus during the last few years. The
makers have at last listened to those who have to use the
tools, and it is now possible to obtain, without much trouble,
cameras and other implements that are easy to carry and a
delight to use.

If a photographer is to do the best and most artistic work
of which he is capable, he must keep his head clear and level,
and be enabled to devote his chief attention to his subject, and
the consideration of the best method of treating it. His tools
and materials must be so arranged that they play into his
hand; this, at all events, is what I find necessary in my own
practice. I take some large-sized pictures; but I do not
possess a camera up to the fifteen by twelve size that I cannot
pick up and carry away with ease, or that has any loose pieces
to mislay or leave at home.

A camera, then—we will take a field camera, for example,
as this book is chiefly on out-door work—should be light, so
that it may be easily transported from one place to another
with no unnecessary fatigue to the operator. A tail-board

camera is the form I prefer. There should be no loose pieces; bolts should be used, where possible, instead of screws; the focussing glass should be hinged to fall and not to lie on the top of the camera, where it is in the way of the focussing cloth and the finder; the back should swing *one way only*—that is, so to give the foreground a better chance of being in focus. I prefer it when it opens much wider than it is usually made to do, say one and a quarter inches in a ten by eight camera; this is especially useful in pictures of the sea. The swing the other way, usually employed for correcting the vertical lines of buildings when the lens has to be tilted up (and which camera-makers will insist upon your having, whether you want it or not), is so rarely required, as to be practically useless in ordinary cameras, and only adds to the weight. I cannot call to mind any occasion on which I have wanted this movement; yet I have had to carry it about with me for five-and-twenty years! There is a new way of making the camera-back, lately introduced, which is very compact. It is easily worked, but too complicated for description. The plate-holders should be of the solid form—that in which the shutters pull completely out. This is a capital invention, for which, I believe, we are indebted to America; the slides are better and cheaper than those of the old book form. The word "slide" should be a misnomer. It is not necessary that the plate-holder should be pushed its whole length, often in danger of sticking in the groove; a slight catch will hold the largest holder securely in its place.

The front of the camera should be made so that the lens may be raised when it is necessary to cut off a piece of the foreground. The piece to hold the lens should not run in grooves, but should be made to fit in its place with a spring. The camera should be easily unpacked, and ready for use at a moment's notice. Photography is not the leisurely pursuit it was in the days of collodion. Subjects continually occur in

a country walk that will not admit of delay. Cameras are now made so that, by touching a bolt or a spring, the tail-board falls down, another bolt fastens the side-piece, and it is ready to fix on the tripod in a few seconds. Sufficient extension should be arranged to allow the use of long and short-focus lenses. Small cameras are better focussed with a rack-and-pinion—large ones, with an endless screw. The stand should be a tripod of the lightest construction that will admit of steadiness, and steadiness does not so much depend on strength of limb as on width of attachment to the camera. Finally, the camera should be so light-tight that it may be. used in the sun without any covering. The solid holders, when well made, are quite safe, and the other parts should not require to have a black cloth wrapped round them. There are times when your subject may vanish while you are blundering over tying out light that should never have the chance of getting in. A perfect camera should be beyond suspicion of admitting light. In the larger sizes of this new form of holder there is danger of admitting light if the holder is not withdrawn or returned very evenly. If part of the holder is pulled out while the other end of it is keeping open the spring which shuts out light as the shutter is withdrawn, light must be admitted. In this case, a black velvet sleeve, made so as to slip easily on and off the end of the holder with elastic, is a perfect protection. In use, it should be fixed on to the end of the holder, and the shutter pulled into it. It may then be removed, as it is only during the pulling out or replacing of the shutter that light can get in.

What particular lenses to use for various purposes has always been a knotty point. As I don't suppose that many of my readers will care to supply themselves with a whole battery of lenses, I think it sufficient to say that that known as the rapid rectilinear form is the best for general purposes. It would also be useful to have a wide-angle single landscape

lens. I usually take two or three different kinds of lenses with me, but, practically, I find the rapid rectilinear does most of the work. It is necessary to guard against the entrance of light through the diaphragm slit in this lens. The little light that comes through the aperture, which never hurts a collodion plate, fogs a gelatine film, especially if the camera is kept waiting any length of time for exposure with the shutter withdrawn. A guard fastened with an india-rubber band not only keeps out the light, but prevents the diaphragm slipping out.

For photographing seas and skies, some other method of exposing the plate than the simple and primitive one of taking the cap off the lens with the hand is necessary. Many ingenious contrivances have been invented for this purpose; but I know of none better than the simple drop shutter. If this should be found to be too heavy there are many forms in the market to select from. Whatever form is used should be made to act by pressing a pneumatic ball and tube. The shutter dropping of its own weight will be quick enough for most purposes; but if it is necessary to give a quicker exposure, any degree of velocity may be attained by the application of springs made of india-rubber bands of different strengths. I strongly object to use, except as a toy or for scientific purposes, any shutter quicker than one-twentieth of a second. Artists do not want to make the mistake of Mr. Muybridge who seems to want to prove that artists are wrong because they do not represent animals as they *do not* see them.

There is one tool which has not yet been invented, but which would be of great use—I mean a portable head and body-rest that would pack with the tripod. Its great merit, apart from efficiency, would be lightness. From my experience with head-rests (whose chief virtue, hitherto, seems to have been in weight) it seems almost absurd to suggest a portable form of this useful but much abused instrument; but I think some-

thing might be constructed in which mechanical contrivance
might take the place of weight. Something based on the
principle of the tripod might be put together for use in difficult
cases, for of all the disappointments that occur to the photo-
grapher, I don't know a greater than for him to find, when he
develops at home a plate he exposed hundreds of miles away,
that he has got a marvellously fine picture in every respect
except that it was entirely spoilt by the movement of one of
the figures. I think that everything in photography has,
in skilled hands, been reduced to a certainty, or as near a
certainty as is possible in this world, with the exception of the
steadiness of the sitter. If this could be attained, a great
advance would be gained. The shortness of exposure at which
we have now arrived is certainly in favour of steadiness ; but
it is a fact that, if a figure moves during a second's exposure
with a quick plate, the blurring is as great as if the exposure
was of a minute's duration. There is an unconscious and
almost imperceptible swing about a standing figure, especially
if in a difficult pose, that would be checked by a very slight
support for the head and back. The expression of the figure
also would be better if supported. When a model has given
all his thoughts to keeping still, he *looks like it*. This is the
cause of most of the stiff attitudes for which photographs
are famous. The figure tries to get into a good position
for accomplishing rigidity at the expense of ease and grace. I
know that there is at least one photographer who makes a
virtue of indistinctness ; but when this curiously appreciated
quality occurs in the head of the principal figure and the other
parts of the picture are moderately sharp it is, at least, a
virtue misplaced.

CHAPTER III.

VERY little true artistic work can be done without some knowledge of the laws of composition. A picture by one ignorant of these rules may occasionally come right and be effective, but he must not expect a series of such accidents to occur. No real success can be hoped for that is not based on a knowledge of the laws which govern the arrangement of a picture so that it shall have the greatest amount of picturesque quality. There is no royal road to success in art. Innate good taste is sometimes relied on, but it is a poor substitute for knowledge. Nothing but a fair acquaintance with the rules of art—at least so far as regards composition and light and shade—will enable a photographer, however intelligent, to succeed in always making the best use of the subjects he may find for his camera. These rules, as far as they can be applied to his art, I have endeavoured to make clear to the photographer in a former work;* I will not, therefore, enter into the more complicated branches of the subject, but it will be convenient to give a short summary or outline here, and refer the student for fuller information to "Pictorial Effect."

The object of composition is to present the subject of your intended picture in an agreeable manner; it is to art what grammar is to literature, and a picture ill-composed is equiva

* "Pictorial effect in Photography," by H. P. Robinson.

2

lent to a book written in slip-shod English. The principal
objects to be sought are harmony and unity, so set forth that
pleasure may be given to the eye without any sacrifice of
the truth of nature. This is done by the preservation of
a harmonious balance of lines, and light and shade. By a
proper distribution of lines and masses, the principal parts in
the picture will be brought prominently forward, and those
of less consequence will retire from the eye, and will support,
or act as a foil to, the chief objects of interest. In short, the
grand fundamental laws of composition may be summed up
very briefly. They are unity, balance, and the adaptability of
the whole to breadth of light and shade, by which the principal
object in a picture—such, for instance, as the head in a
portrait—is brought forward most prominently, yet united
with the other parts, so that the eye may first see the point
of chief interest, and be gradually and agreeably led over the
picture.

If you will examine any of the pictures produced by great
artists during the last three hundred years, you will find that
the arrangement of them is all more or less based on a few very
simple forms, and these forms may be traced running through
all kinds of pictures, from the simplest landscape up to the
grandest historical subject. And if you care to go back more
than two thousand years, you will find that the laws of com-
position, as we have them now, must have guided the sculptors
of that time. The Frieze of the Parthenon, by Pheidias, in
the British Museum, is a fine specimen of formal composition,
showing subtle beauties of the most intricate and scholastic
order. These forms partake of the leading idea of the triangle
or pyramid, the diagonal line and its contrasts (which is a
variation of the same thing), and the circle with its modifi-
cations.

Of the first importance in composition is balance. All lines
should be balanced or compensated. Without a due regard to

this important quality a picture would appear ready to fall to pieces.

Example :—Lines running in one direction, whether parallel or otherwise, would give a weak and awkward appearance. A sense of falling is conveyed to the mind by lines repeating each other thus ///// When lines of this character occur, it will be always found possible to produce compensating lines in other parts of the picture, thus //\ or if lines run diagonally down a picture thus ≡≡ A /B a compensation for the lines A is found in the line B.

There are many ways in which oblique lines may be compensated, in a great measure depending on the ingenuity and skill of the artist. Here are some examples.

In the lane scene, the falling lines of the foreground tree on the right are supported by the opposing lines of the more distant trees on the left. The sheep also greatly aid in preserving balance. In the lake scene, a different disposition of balancing lines is shown. The lines of the near rocks and foreground oppose the lines of the mountains, and the dark foreground contrasts and sends back the extreme distance.

The diagonal line is very suitable as a framework on which to construct a composition; but the base of the angle must

be supported. This may be done by the opposition of lines as already shown, or by contrast, which in art often supplies the place of balance. In the sketch from a photograph by Mr. Mayland, the darkest spot—the boat—is opposed to the highest light, and, being the nearest object, is opposed to the most distant, thus giving effect to each other by contrast; and the boat, being at the base of the angle, supports the whole and acts as a kind of key to the entire framework of the composition.

If the student will imagine the boat removed, or cover it with his finger, he will find that the composition falls to pieces.

 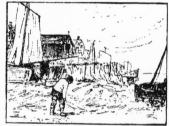

The fishing village will appear to have nothing to support it —no solid foundation. The lines running to a point in the distance appear to want collecting together and regulating; the distance appears to come forward, and parts do not take their proper relation to one another. This form of composition, with its endless variations, is most valuable to the landscape photographer, because it is more within his control than any other. It must be a very awkward landscape that would not admit of a contrasting or balancing spot of either light or dark, and this can nearly always be supplied by a figure or figures. Lines for the purpose of contrasting the leading forms of the view may be supplied by the sky; in the last illustration the lines of the clouds are made to oppose the lines of the village, and the direction of the lines of the old fisherman who is setting out his

nets on the shingle to dry also serves to contrast tne leading lines of the composition.

The next illustration, Sir A. W. Callcott's "Dutch Peasants returning from Market," in the National Gallery, shows the application of these rules in an important picture. The diagonal composition will be easily seen, so also will be the balancing spot—the girl in front—and the contrasting lines of the clouds.

Turner's "Fighting Téméraire" is also composed on the same lines, which the student will now be able to trace for himself.

Surely this picture of the grand old fighting ship being tugged to her last berth, perhaps to be broken up, by the business-like little steamer, is the most pathetic ever painted from which humanity is absent.

It is not necessary that the ruling point, or key-note, should be at the side of the picture, and under the extreme distance. It will be found, by an examination of the best landscapes, to vary very considerably; but if it be an important object, it

will never be found exactly in the centre, or under, or in a
line with, any other important or prominent form of the same
size or character.

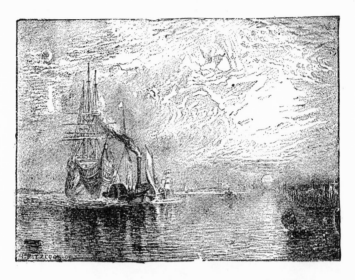

Here are two other variations of the use of the balancing
spot. In the first instance, the spot is obtained by **a** dark
figure—in the other, by a white swan.

It is not absolutely necessary that the landscape should rigidly
follow the diagonal line—there are endless variations of the

principle; but I give this, the plainest and clearest of all the rules of composition, prominently, because it is a key which, once mastered, will enable the student to unlock the secrets of the most complicated designs, and render his future studies easy.

It would be useful practice for the student now to study some good pictures with a view to analysing their composition as far as he understands it at present. Perhaps the most readily accessible would be found in illustrated books. The student may rely on any illustrations by Birket Foster as being sure and certain guides to good composition. If he can get any of these —they are very plentiful—let him look for the balancing spot, and learn to recognize it under all its disguises. He may be quite certain that it is always there. I never saw the slightest sketch by this popular artist that was deficient in balance, and his subjects are usually within the reach of the photographer.

We now come to the consideration of pyramidal forms, an extension or multiple of the diagonal line, very suitable for the arrangement of single figures and groups, but which also applies to landscape—and, indeed, every other branch of art. For the purpose of elucidating this method of composition, it would be well to analyse a picture that has already been produced by photography. We will, therefore, take the frontispiece of this volume, " A Merry Tale "—like Touchstone's Audrey, " A poor thing, but mine own." If the student feels a desire for going further into this part of the subject, he will find it much more completely detailed in " Pictorial Effect " in a minute analysis of Wilkie's " Blind Fiddler."

In pyramidal composition the group should consist of a series of irregular pyramids. A perfectly symmetrical group would want variety, and be too formal and stiff. These series of pyramids should be contrasted and balanced in various ways, and yet so joined together as to produce unity and harmony; the whole arrangement should lend itself to an agreeable breadth of light and shade, and leading sinuous lines should run through

the composition, leading the eye from part to part, and uniting the whole together.

The first great thing in making a picture is to have an idea; but we shall come to that further on. At present we have only to consider the mechanical arrangement of a group; but every picture should have some leading idea—some special fact —to which the parts lead up and intensify, and nothing should be allowed to come between the spectator and the leading idea.

In " A Merry Tale," the story-teller forms a pyramid in herself, the arm and hand contrast the pyramidal line, and lead to the other figures of the group. The hand—a point on which the whole group depends—had to be made conspicuous. The figure in a straw bonnet forms a pyramid in herself, and repeats with variation, or echoes, the principal figure. Repetition is a fine quality in composition, but too subtle a part of the subject to enter into here. This figure, in combination with the figure behind her, makes another pyramid. This form is also emphasized with the stick, which is of further use in affording a straight line contrasting with many curves, and in being part of a curved leading line extending down the stick through the basket, and uniting the story-teller to the rest of the group. The head of the standing figure forms the apex of the complete pyramid, which is contrasted by the figure lying on the bank. The foreground objects serve to balance the composition, and are analogous to the " spot " so often referred to, and help to connect the figures. It would have been better if the basket and jug had been moved a little more to the right, and the jug a little nearer the camera. The grouping would also have been improved if the upright tree (which is useful as a contrasting straight line) had been a very little more to the right. It would then have been the apex (as it nearly is now) of another pyramid, uniting the whole picture. Another fault in the grouping is, that the path is too nearly in the centre; this could have been easily

altered by a slight movement of the camera. The last thing to notice is, that the whole of the figures are combined by a circular base line, making the whole into a compact group. The composition of this picture is further referred to in Chapter VIII., "The Genesis of a Picture," in which it affords an opportunity of showing how a picture originated and was carried out.

There are many other things to consider in the study of composition, such as repose, fitness, symmetry, repetition, variety, unity, subordination, truth, expression, proportion, etc.; but the primary necessities—the simple law of balance and contrast—will be sufficient here.

It is a maxim in art, that art should conceal the art. This simply means that there should not be an ostentatious display of knowledge. That picture which looks most like nature to the uninitiated will probably show the most attention to rules to the artist. As Leslie says in his "Painter's Handbook," "The axiom that the most perfect art is that in which the art is most concealed, is directed, I apprehend, against an ostentatious display of the means by which the end is accomplished, and does not imply that we are to be cheated into a belief of the artist having effected his purpose by a happy chance, or by such extraordinary gifts as have rendered study and pains unnecessary. On the contrary, we always appreciate, and therefore enjoy, a picture the more in proportion as we discover ourselves, or are shown by others, the why and the wherefore of its excellencies; and much of the pleasure it gives us depends on the intellectual employment it affords."

CHAPTER IV.

LIGHT AND SHADE.

IT might be said that a knowledge of the most effective arrangements of light and shade would be of little use to the landscape photographer, in consequence of the little control he has over the lighting of his subjects. It is true that he cannot throw the light as he pleases over his subject, any more than he could really move mountains if they interfered with his composition; but a knowledge of how to mass light and shade, to which the name of chiaroscuro has been given, will enable him to know better what will make a good picture, and to select with more certainty.

The photographer, like the engraver, produces his effects by light and shade; he owes nothing, legitimately, to colour, and being deprived of the latter attractive element—which covers so many defects in painting—his chiaroscuro need be the more perfect.

The word chiaroscuro, derived from the Italian, and meaning light-dark, by no means clearly conveys the idea of what it is intended to express. Usage has, however, reconciled us to the use of the term to express, not only the means of representing light and shade, but the arrangement and distribution of lights and darks of every gradation in masses in a picture, so as to produce pictorial effect, just as the word composition is used to express the pictorial arrangement of lines.

The chief object to attain by the help of chiaroscuro is

breadth of effect, by dividing the space into simple masses of light, shade, and gradation, preventing that confusion and perplexity incident to the eye being attracted by numerous parts of equal importance at the same time, and to place before the spectator at the first view the principal object represented, so that the eye may see it first, and be gradually and insensibly led to examine the whole picture; to keep parts in obscurity, and to relieve others, according to their pictorial value. It should also be of use to aid the sentiment and expression of the picture.

It is admitted by all writers on the subject, that mere natural light and shade, however separately and individually true, is not always legitimate chiaroscuro in art. Howard, in his useful "Sketcher's Manual," to which I am indebted for several hints in this chapter, advocates the use of "arbitrary and artificial shadows," when necessary, for pictorial effect, "whether possible to be found under such circumstances in nature or not," and he gives an instance in a picture of Bonington, in which, for the purpose of obtaining a wedge-formed mass of dark, a shadow is thrown upon a cliff that could not by any possibility be there. This might have been allowable fifty years ago; but since photography has taught art to have some regard for the truth, I should hesitate to add a shadow to a picture if I could not find a natural excuse for it. But the excuse need not be included in the picture—the light from a window, for instance, may be shown without showing the window—any more than it would be always necessary to show the sun when sunlight is represented.

Yet we have the great example of Sir Joshua Reynolds for the artifice. In many of his pictures will be found broad masses of shadow, which could only have been thrown by the sun, while the lights are such as would be given by ordinary daylight. This is false to nature, but we cannot help admiring the effect, which is well shown in this sketch of Robinetta,

from the picture in the National Gallery. In photography we must not indulge in such license. It would be very unwise to use any effect which could not be shown to arise from a natural cause. Not, however, that it is necessary to show cause to every inquiry. An artist is not obliged to damage the effect of his work by explaining every little detail as though it were a patent machine.

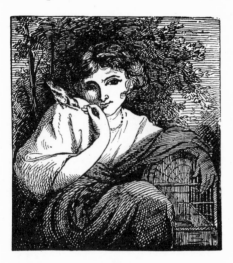

In nature, generally, light is shed indiscriminately on all things : subordinate objects may be brought forward prominently, and important features may be cast into shade. It is not so with art. Art must select and arrange, or it is no longer art. A work of art is a work of order. But, although separate, unselected truth may not be true art, true art requires that there shall be no absence of truth. In no part of art is judicious selection of more consequence than in the choice of light and shade, especially in photography, because chiaroscuro so governs the effect of a picture, that a subject may be either beautiful or the reverse, as I shall endeavour to

show further on, according to the way in which it is clothed
in light and shade. Chiaroscuro not only adds a beauty to
perfect outline, but transmutes ugly, and sometimes disgusting,
subjects into artistic gold. Rembrandt's pictures, often ill-
drawn, and absurd in design and invention, always vulgar in
choice of form, are of priceless value for their marvellous
chiaroscuro. In short, a beautiful picture can be made out of
ugly materials, if we can throw over them the glamour and
witchery of perfect chiaroscuro.

As I have already said, the principal object to attain is
breadth. It is, perhaps, necessary to explain that this does

not mean a broad space of equal light or shadow; such an
arrangement would result in flatness, as will be evident to the
photographer if he will take a view with the sun shining
behind his camera. He would find a flat mass of detail without
shadow or relief. It would be very different if the sun were
so situated in relation to the view as to give a broad simple
light over part of it, the rest being in shadow. In the sketch,
the sun is setting to the left out of the picture, the foreground
is in shadow, and the sky rather dark but full of gradation,
leaving the mountain in a fine breadth of sunshine. This is
one of the most agreeable effects in art. I may as well point
out here, as I want to insist on its value all throughout this
book, that the composition in this sketch is balanced against

the light distance, and towards the end of the falling lines by
a balancing spot ; in this instance, it consists of a combination
of the lightest light and darkest dark in the picture. The
word breadth is used in contradistinction to the term spottiness,
and equal lights or equal darks would look spotty. Just as a
degree of irritation to the touch arises from uneven surfaces,
so all lights and shades which are interrupted and scattered
are more irritating to the eye than those which are broad and
continuous. It must not be supposed from this, that extreme
contrast in light and shade in the proper quantity, and in the
right place, is not agreeable, for upon contrast and opposition

much of pictorial effect depends; but it is the flickering lights
and perpetually shifting glare of ill-managed chiaroscuro that
keep the eyes in a state of constant irritation, and distract the
attention from the subject of the picture. Objects which in
themselves possess no interest are frequently made to delight
the eye from their being productive of breadth. Some pictures,
though bad in every other respect, but possessed of breadth,
attract and arrest the attention of the cultivated eye; while
others, admirable in detail and colour, but in which the
harmonizing principle is wanted, will often be passed over as
uninteresting.

Light and shade varies so with the subject, that it can
scarcely be reduced to anything like a system. We speak of
the laws of art, but it is very difficult to formulate them.

There are a few general arrangements, however, which the photographer would find valuable to have always before him, and they are only, as it were, duplicates of the laws of composition in line and form.

The centre is the weakest point of a picture. Neither the principal object nor the chief light should be situated in that place where lines drawn from the opposite corners would inter- sect. A position either immediately above, below, or at the side of this point would better satisfy the requirements of pictorial effect. In the left-hand illustration on the opposite page, the regularity of the shape destroys all picturesqueness.

The one on the right, on the contrary, affords every facility for pictorial effect. There is concentration of light, breadth, gradation, and variety.

When the light spreads through the picture, it should never be allowed to form a horizontal or vertical line. This refers to the general mass of light as shown in the diagrams. The horizontal bars of light seen at sunset are often very beauti- ful, so also are the lines of the sea, which give a sentiment of repose to be produced in no other way; but, even in these cases, the lines of the clouds are better broken by the con- trasting shapes of foreground objects, such as trees in land- scapes, masses of cloud or the masts of a vessel in sea views. In short, when the light falls, or is spread diagonally, it is

more picturesque than when it is arranged horizontally or vertically.

It is desirable that all lights should have a focus, just as

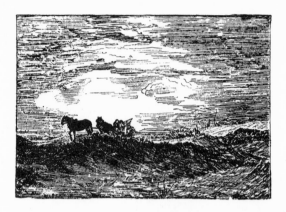

light falling on a globe is more brilliant in one small spot than on any other part; and all lights should be treated as parts of a whole, and subordinated in various degrees to the

principal light. The illustration—"Showery Weather," by F. R. Lee—represents a simple plan of chiaroscuro much used by many artists, and is beautiful from its simplicity. The lightest light is opposed by the darkest dark, and the light fades away from the focus in every gradation of middle tones. The two extremes of black and white assist each

other by contrast, and produce a forcible effect with great breadth.

It will be found that the beauty of effective light and shade consists chiefly in wedge-shaped masses; in the diagram, the whole mass of shadow takes this form. The effect may often be seen in moorland scenery, or a flat country, or at the seaside when the cliffs take this shape; but, of course in this form, any subject may be included. The shadow of a cloud may be thrown over the distance, while the foreground may

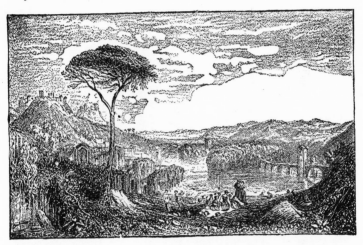

be in sunlight, or the effect may be caused by a belt of trees, or ships, or a city. A mass of extreme dark will be found very useful in the foreground to give support to the wedge and expanse to the distance. If the mass in the foreground consists of an object in which are combined the extremes of black and white, it will throw the rest of the picture—consisting of gradations short of black and white—into harmony, by creating a focus, as it were, more brilliant than, and overmastering, the other lights and darks.

Turner's pictures are often composed on this principle. **In**

" Childe Harold's Pilgrimage, Italy," a single mass of extreme dark of agreeable form—the stone-pine—is relieved against a light sky; and some bits of extreme light are introduced into the foreground, while the rest of the picture is composed of gradations within the extremes of darkest and lightest. In this arrangement Turner imitated Claude. The next sketch is from a beautiful little picture by Claude in the National Gallery—"The Annunciation"—in which the student will trace the same disposition of light and shade. These pictures

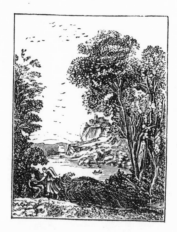

are types of many others by the same painters. The application of this principle may be reversed. A single mass of light may be relieved against a dark background.

But although there should be a principal light or a principal dark in every picture, this light or dark should not stand alone. No light should be allowed to be single or isolated, but should be repeated or echoed—not in its full force or quantity —there must be no rival near the thron —but in inferior degree. The wonderful charm of Rembrandt was not brought about by the startling use of extreme darks and lights. It was by the subtle use of repeated lights in marvellous grada-

tions that this great master of chiaroscuro worked his enchant-
ments. These reflected and repeated lights—repeated, however,
in a lower key—harmonized and mellowed the violence of the
extremes of light and shade, which are always to be found in
his pictures.

This is well shown in the sketch of his " Adoration of the
Shepherds." Although the child occupies so small a place in
the picture, it is the spot which instantly attracts the atten-

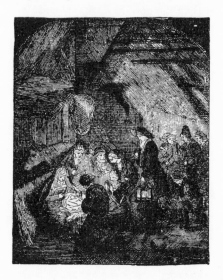

tion. The bright light is opposed by the strong dark of the
kneeling figure, and the light is diffused with the greatest
skill through the rest of the space. The chiaroscuro of this
picture is not unlike that shown in the diagram of diagonal
light and shade on page 30.

The next illustration, from a drawing by F. W. Topham,
shows the application of the rules of art we have been dis-
cussing; it is a fine example of breadth, and is so arranged
in its lines as to admit of very effective chiaroscuro. The

student will now be able to easily analyse the composition; the pyramidal principal group, balanced on the one side by the door, with its straight upright lines, and on the other by the cupboard in the wall, this being properly kept subordinate to the first-mentioned, which is the primary balance. The bundle hanging from the roof over the bed is not without intention, but is placed there to form the apex of another pyramid, which corrects the formality of the chief group. It will be noticed that the deepest dark—the old woman's head—

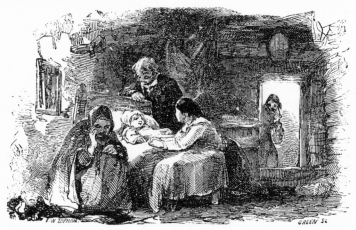

is brought into immediate contrast with the highest light —the baby in the bed. Another contrast is also obvious here— youth and age. The other portions of the picture are kept in varying, but intermediate, tones, thus securing the greatest amount of brilliancy and breadth. It is probable that in the original drawing the sky, seen through the open door, was more subdued in tone. There is a sentiment in the composition and chiaroscuro quite apart from, yet very suitable to, the subject.

Having given a short outline of composition, and light and shade, we will now endeavour to put the knowledge gained into practice.

CHAPTER V.

IN THE FIELD.

BEFORE you go out with a camera in your hand, it would be well to decide what you intend to do. A camera, if of any size, is but an encumbrance the first time you inspect an unknown district in search of subjects. A note-book and pencil are much more appropriate implements, and a view-meter may be useful, but the camera is best left at home. Of course, I know that when you are hurried, as on a tour, you have no time to make these preliminary arrangements; but, under such circumstances, you are not so much looking after pictures, as endeavouring to secure reminiscences of your travels, in the nature, as it were, of sketches. Our present object is to make pictures. Equipped, then, with note-book and pencil, you may go forth prospecting.

When you meet with a scene that strikes you as giving unusually fine opportunities for obtaining a good picture, don't throw it away by making a careless use of it, such as taking it at the wrong time of day, or without the necessary figures and accessories to make all out of it that can be made. Don't leave the arrangement of it until you want to expose the plate. Think it all out thoroughly before the time of action comes, so that you may have nothing else to do but to execute when the moment arrives—when the weather is propitious and all things are conducive to a successful result. Waste your time and plates as much as you like, but don't throw

away a fine subject. Besides being the nearest road to success, it is a saving of time to " think before you leap."

As an illustration of how time may be saved by preliminary inspection, I may state that in addition to walking several miles, I once exposed thirty 15 by 12 plates in nine hours. These were all landscapes with figures—each, more or less, telling a story. A few of the plates were used for duplicate exposures, so as to make more sure of difficult or favourite subjects ; but twenty-two of the resulting pictures have since appeared in exhibitions, and some have taken medals, so that their quality must have been up to a certain mark. This rapidity is easily accounted for. We were staying at a country house, and had been troubled with unsuitable weather for eight or ten days, and had little else to do but look out subjects and make a complete study of them. So the work was all cut and dried when the fitting day arrived. And what a day it was ! It was worth waiting for. The light seemed to alter to suit every effect I desired. A slight sketch was already made for each picture, the subject and title decided, the models selected, and the exact place and pose assigned to each figure. There was nothing left to be done, speaking metaphorically, but to turn the handle and grind out the tune.

When a view is selected, you should consider it as a painter would if he were going to make an important work of it. You have not so much power of modification as he possesses, therefore your skill and ingenuity must make up for the loss. In most cases, there is more to be done than some photographers are aware. The chiaroscuro is very considerably in the photographer's hands. It is proverbial that everything will come to him who knows how to wait ; and if he is not hurried he can select from twenty different effects of light,—from the long shadows of early morning, through the almost shadowless noon, to the softened lights and deepened shades of evening.

The composition, also, is capable of great modification. Variations of a foot or two in the point of view will often very materially alter the arrangement of the lines and masses. The removal of the limb of a tree or less obtrusive twigs and branches, will sometimes disclose a picture which scarcely existed before. The opening of a gate may serve to give variety of line and opportunity for figures that did not previously exist. I have even seen the flood-gates of a weir opened, so that a photographer might obtain the effect he required. When all has been done that can be done, take yet another look round to see that nothing has been forgotten. Above all, don't trust to your memory for anything. Make sketches and notes, so that nothing may be left to chance; you will then be free in your mind to proceed with the selection of your next subject.

As there are no two things alike in nature, no two blades of grass, nor even two accurately corresponding sides of the same face, it is difficult for me to be very particular and minute about the arrangement of any special view or views, and what I have to say will consist a good deal in negative advice. I can only refer you to the last two chapters, in which some idea of the guiding principles of composition are sketched, and hope they will help you to arrive at success. I can, however, refer slightly to some subjects that have not yet been much hackneyed or made the common property of every photographer, like the ruins of our castles and abbeys, our churches and waterfalls.

Enough use has not been made of the sky. We sometimes see a photograph of a good sky with a bit of sea—and the use of a second negative in ordinary landscapes has fortunately become common, notwithstanding the opposition the method met with for several years—but we seldom see what might be called a sky picture; that is, a picture the principal subject of which is the sky, the land and figures taking a

secondary position. Here is a slight sketch of the kind of effect I mean.

The illustration to Chapter XV.—" Is it a dog ? "—is also an example of same effect. The sheep and foreground occupy little more than one-third of the space, and the larger portion is occupied by the sky.

The peculiar charm of aërial phenomena is too much neglected. The clear, bright day, when all objects are sharply

defined, is still the sort of weather in which the photographer delights. But there are lovely pictures to be got in the mist, though the opportunities for these effects are rare. Some years ago I rose very early each day for a week in the attempt to get a group or two of mushroom gatherers in the morning mist. But " the breezy call of incense-breathing morn " was wasted, and I was not rewarded for my constancy. Who has not seen and admired the beautiful, dreamy, indefinite effect of mist among the nearly leafless trees of autumn, when the sun, trying to pierce through the

vapour-laden atmosphere, has reproduced a scene from fairy-land?

Such a scene as this I saw a day or two ago. I was out with a shooting party, and was one of what is called the "forward guns." I was waiting at the end of a beautiful covert. A fine mist partly obscured everything, but so slightly that the strong sunlight penetrated and illuminated the foreground, which consisted chiefly of a light, broken clay bank that gave great breadth, and threw back the mist-enveloped trees. A keeper in dark brown velveteen, with a black retriever at heel, listening to the beaters working their way from the far side of the wood, added life to the scene, and gave point to the composition. It was a quite possible subject. I was forgetting all about the shooting, when a dead pheasant plunged at my feet, and awoke me from my dream.

In the selection of a view, great attention should be paid to the foreground. The foreground is of so much importance that I do not hesitate to say that if a view is not well-fitted in this respect, it can never be an effective picture. An uninteresting plain of smooth meadow, for instance, is sufficient to ruin a view, however beautiful the middle distance and distance may be. A landscape photograph seems to require a good foreground more than any other kind of picture. Other parts of the scene must compose well, and be in harmony, but it is not necessary that they shall be of importance, while, if the foreground be weak or ill-composed, no strength or importance in other parts will save the picture.

It is fortunate, however, that the foreground is just that part of the scene over which the artist has most control. It is not every subject that has a good foreground ready made, but it is often within the power of the photographer to do well with apparently very indifferent materials. A spot of

black or white put in the right place may turn a poor subject
into a perfect picture. What the spot shall consist of must
be left to the ingenuity or readiness of the photographer. It
may be a human figure, or a bird, or a beast, or a fish—in
one case I have actually seen it consist of a fish—but the
requisite balancing or contrasting spot, whether white or
black, or both, must be got, as has already been insisted on in
the chapters on "Composition," and "Light and Shade." It

would be useless to go into any detail as to the arrangement
of foregrounds—the disposition of each can only be settled
as each case arises; but I here give an illustration of how
a most uninteresting foreground has been ameliorated by the
introduction of figures.

In this case there was a pretty, varied belt of trees in the
middle distance, and a wooded height in the distance; the
foreground was a plain piece of park- and, with useful clumps
of gorse and bracken scattered about; but a photograph of
this would have no claim to be a picture. The simple intro-
duction of a couple of figures with some little action in them

breaks up the plainness of the field, gives interest, and accentuates the composition.

It will be well to remember that the more simply and broadly foregrounds are treated the better will be the result. Indeed, it cannot be too strongly impressed on the photographer that the more simple his subject altogether—if he aims at fine art—the better it is adapted to his means. The best painters are often content with the simplest subjects; the inexperienced are too apt to select the most ambitious themes. The young painter struggles with the highest flights of history (or he used to do so, he is wiser now), but the great artist often finds the highest art in the simplest subjects. It has been well said that "true genius was never better displayed than by certain great landscape painters in the happy simplicity of their noblest subjects."

The student having now made up his mind what he is going to do, may go and do it. He should see that his mechanical arrangements are so complete and easily accessible that he will scarcely have any necessity to think of them; but for fear he should have to do so, let him put his hands in his pockets and get an assistant to look after the luggage, for it is not easy to arrive on the ground capable of good work if you have been doing duty as a heavy porter on the way. All preliminaries should be so complete that no doubt or hesitation should be possible. The battle should be fought and the victory won before the cap is taken off the lens or the trigger of the shutter is pulled.

CHAPTER VI.

WHAT TO PHOTOGRAPH.

"WHAT is beautiful must be decided by each man for himself, and at his peril," says an able writer. "There are some who maintain that all nature is beautiful. Fortunately, we can now disprove this monstrous position by our daily experience of photographs. Even if they were quite true in effect, form, or expression, they would often be more or less ugly. They are usually planned and made by men of some chemical knowledge, but tasteless, and entirely unacquainted with fine art. Consequently, the photographers unconsciously offer us the mean and ugly mixed up with some beauty."

The writer, of course, refers to unselected nature, or nature selected without intelligence. The photographer can have no claim to the proud title of "artist" if he is content to take things as they are. Art has been said to exist in all nature, and we have only to learn the art of seeing it pictorially, to reproduce it in our paintings and photographs. This is true enough as far as it goes, but it does not go far enough. As I think I have said before, *a work of art is a work of order*, and if the artist is to put the stamp of his own mind on his work, he must arrange, modify, and dispose of his materials so that they may appear in a more agreeable and beautiful manner than they would have assumed without his interference. In the field the artist may select the time of year, the time of day,

the direction of light, the conditions of the weather—for which he has sometimes to exercise one of the greatest qualities of a photographer, patience—the point of sight, and to a great extent the arrangement of the masses. Figures may be introduced to join two masses of either light or dark together, and to give life and motion to the scene, scale to the parts, balance to the composition, and—it is only carrying the thing a little further—a house may be pulled down or a tree uprooted. That this is not a fanciful statement, I may say here that I once employed two men a day in clearing a wood to afford access to a particular scene I wanted to photograph. In the studio the effects are still more under the control of the operator. The arrangement of light, the pose, backgrounds, accessories, are in his hands, and, if he is a master, he can also within limits control the expression of his sitter. In this chapter on " What to Photograph," however, we will forget the studio, and keep out in the fresh air.

In taking local views, art must, to some extent, be sacrificed to utility. It is not essential that a local view should be pictorial. If some picturesqueness can be secured, so much the better; but the object is to give a portrait of the place. If a castle is the object, it must be made to appear bold and prominent, and, above all things, clear. Atmospheric effect, so beautiful in other pictures, must not be allowed to interfere with the clearness of a local view. If a distant mountain comes in the scene, it must be made to look as large and prominent as possible. If a church is the subject, it is more to the purpose to show every porch and window than to get a good effect of light and shade. But my object in these chapters is to help the student to make a picture which may have a just claim to be called a work of art, and local views in their intention are more nearly allied to maps and plans. Nevertheless, a careful study of the rules of art will enable the photographer to improve these useful productions, and the

very fact of representing them may add interest to a scene. As Browning says :—

> " *For, don't you mark, we're made so that we love*
> *First when we see them painted, things we have passed*
> *Perhaps a hundred times, nor cared to see.*"

A local subject need not be taken at its worst. The ugliest thing with which man has disfigured nature—a square block of stuccoed house—may have to be photographed ; it may be the first hotel in the town, for instance, and an important local view. I have seen such an object taken squarely in a full light, when it would have been easy to get it in perspective

by moving the camera a few feet. I purposely give a plain and bald example, that the effect may be more easily seen. The principle may be applied to most subjects.

Many photographers find it difficult, even in the most beautiful country, to find anything to photograph, whilst others cannot turn in any direction without seeing subjects for their art. The only difference is, that the first-mentioned have learnt to see, and the others have not. Subjects, or the materials for subjects, abound everywhere ; but the art of seeing them is a cultivated sense, and does not come by nature.

It is a great fallacy to suppose that all art, even very good art, is the work of what is vaguely called genius, except that

genius which has been admirably defined as the capacity for taking infinite pains. I willingly admit that the greatest art is the product of inborn genius—added to labour—but there is very little work in any art that touches the highest point, and, therefore, little that is not the product of acquired talent.

The constituents of a picture are plentiful, but they have to be found and arranged. A picture may contain a vast amount of landscape material, without being in the strict sense of the word a picture. It may contain a sufficient number of facts to make up half a dozen pictures, without being one in itself. There must be something more than imitation. Imitation, merely, is not sufficient for art, though it is a great requisite, and, in photography especially, is a factor which must not be left out of the reckoning. It must never be lost sight of, although Ruskin says that the pleasure resulting from imitation is the most contemptible that can be derived from art. It is at once weak, indolent, and spurious art which breaks down the natural for the sake of the artificial; it is easily detected, and the trick exposed. At the same time imitation is no more to art than grammar is to language. But imitation may be subordinated, even in our imitative art. Literal fact may give way to higher truth.

It has been the practice for photographers, especially the least experienced, to select fine scenes in nature for the purposes of their art; while simpler subjects, if properly treated, are much more likely to yield picturesque effects. A collection of views of cities, or other famous places, will pass from the mind and be only remembered as a set of very fine photographs; while a few simple photographs of bits of country with a figure or two, well posed and lighted, will dwell on the mind for years. Why is this? It may be explained in two words—"human interest." There is the interest in the figures themselves apart from the artist, then there is the interest in how the artist has done his work. Then, perhaps,

the title will help, as it should do. There is no scope for a title in a view; you can only call it by the name of the place it represents; but in pictures of incident, although the subject should describe itself, the title is not unimportant.

Some of the finest effects are those which consist of broad masses of light and shadow. Breadth of effect is one of the most pleasing qualities in art; it harmonizes everything, and will give beauty to the ugliest objects. A great deal may be done by selecting the time of day. A subject that may be flat and weak with the sun shining full on it in the morning, may have every element of the picturesque in the afternoon, with the sun shining from the side, or behind the view. To select a view with the sun shining in the front of the lens was once thought to be most unorthodox. It used to be a direction to the young photographer to have the sun at the side of the view, perhaps a little in front. It is curious how we all run in grooves. It is only during the last few years that photographers have shown any disposition to throw off their trammels, and take their pictures where they found them so lighted as to be most conducive to pictorial effect. It is but recently that photographers have dared to try to be original, and then only after a good deal of "showing how."

In connection with the effect of lighting just referred to, I may mention a picture of which a large number has been distributed as presentation prints, and in other ways, called "Wayside Gossip." (See Frontispiece.)

I have often considered this particular view as to its capabilities of affording a picture, and given it up as not containing sufficient interest. It was nearly south, and I had either seen it in the morning or the evening, when the light fell flatly upon it. But one day I passed the place at noon, and found it changed as if by magic—"the daily miracle of the sun"—into a most picturesque scene. The trees, formerly an uninteresting collection of stems and leaves, were trans-

formed into broad masses of shadow, delicately tipped and outlined with silvery light. The foreground was a fine breadth of light. There was little thought required to decide where the figures ought to go. The spot on the lake-dam, where the two figures are seated, seemed to insist that some figures should be placed there. After one plate had been exposed, it struck the photographer that a third figure would add variety and interest, and, perhaps, a title, so another model was added to the group—the standing figure resting on a stick—and a second plate exposed without moving the camera. If my reader has an opportunity of seeing a full-sized print of this picture, he will notice the almost stereoscopic effect of figures lighted in this manner. The standing figure in particular seems to come quite solid from the background. This is due in a great measure to the edging of light round the figure which this kind of lighting gives, and the gradation in that part of the landscape which forms the immediate background.

Gelatine plates practically open up a new world to the photographer. He can get at subjects that hitherto he could not approach, and he can depend upon securing them, whether nature is playing with thunderstorms or sunbeams, with considerable certainty. He is also in a much readier state to take a picture when called upon suddenly, than the old process would allow. This should induce him to take advantage of what may be called the accidents of nature. Many of these accidental effects have never been well represented in photographs; such as a rain-cloud, for example, or the weird effect of cloud shadows passing over hill and valley. Transient atmospheric effects are always worth securing; so also are animal studies. It would be impossible for a photographer to decide beforehand that he would do a picture of cows in a stream; but he should be ready to avail himself of such a chance if it should occur.

As another instance of accidental effects, I may mention

4

that I have several times exposed a second plate on a view containing water, because, after the first had been exposed with the water still, a puff of wind had ruffled the lake in places, and added surface to the mirrored depths. Quick plates enable the photographer to see the beauty of these accidents in nature. In the olden time a puff of wind would have been considered a nuisance.

CHAPTER VII.

MODELS.

IT is only of late years that photographers have given anything like adequate attention to the figures they introduce in their landscapes. Anything that happened to be at hand, from a Cockney tourist to the porter who carried the camera, was once thought quite good enough for every occasion. Now, I am glad to see, something better is thought necessary, and if this is not obtained, the photograph is a very ordinary photograph indeed; and is usually, if admitted at all, passed over in an exhibition as a commonplace production. The sins against fitness become fewer every year, while anything really vulgar in taste is extremely rare.

There are those who go for absolute purity of production, unmitigated nature, who will admit nothing in a picture but what is indigenous to that picture, so to speak; but Art, according to Lord Bacon, is man added to nature, and unmitigated nature is certainly not art. I do not fear to say that nature alone, as a picture, has far less interest than the same nature represented by a great artist. "What are you painting?" said I to one of my painter friends when we were out on a certain painting and photographing excursion; "your sketch does not seem, if I may be excused the criticism, to be exactly a coloured photograph of the scene you have before you." "I am not painting a local view," was the reply, "I am painting what nature suggests to me." Now, as regards

models, I seldom find the "real thing" to quite answer my purpose. The aboriginal is seldom sufficiently intelligent to be of use, especially if you have "intention" in your work.

I remember a case in Wales very much to the purpose. Some artists who were of our party came home from a walk one day, enthusiastic about the beauty of a girl they had seen in a field two miles away, planting potatoes. I must go next day and photograph her. I went, and found they had not exaggerated; she really was a beauty, and her clothes also were lovely, both in colour and in dilapidation. Knowing how shy the Welsh peasant is, I got the gamekeeper who carried my camera to speak to her first, and I approached the subject warily by beginning an agricultural talk with her mother. After a time I got the girl to stand for a picture, but it was a dead failure—all the "go" was gone out of her, and she looked as frightened as a hunted hare. After another trial, she objected to be tortured any more, and ran away. I persuaded her mother to bring her to the house next day. She came, and I got the housekeeper to talk to her, and left her for an hour to get used to the place and people. I then tried a picture. I posed her by the side of a pool with picturesque surroundings. Naturally she had a most winning smile, but I could not succeed in calling up anything better than a scowl. I got a fine picture in every respect, except in the one essential—the expression.

But if fine nature, in the way of natural models, is not to be obtained, art supplies the remedy, as I am now going to show.

I am quite conscious that I am laying myself open to the charge of masquerading, but art is a state of compromises and sacrifices, and I cannot but think that what is lost in absolute unrelenting naturalness when substituting trained models for the newly-caught raw nature, is compensated for in many ways. Graceful figures, if not over-done, give an ideal tinge

to the picture that lifts it above the cleverest transcript of mere prosaic fact.

My models may be called to some extent artificial, but they are so near the real thing as to be taken for it by the real natives, just as the trout does not seem to know the difference between the natural and the artificial fly. One day two of my models were walking across the park, and a gamekeeper, seeing them for the first time, made after them, shouting in the high tone that sounds like quarrelling to the stranger when he first hears it in Wales. As they would not stop he did not hesitate to give way to all he knew in both languages, and did not cease to vituperate till, getting near them, he found to his dismay they were " the daughters of the house."

This, I think, shows that our imitation is sufficiently like the original for artistic purposes.

My models are trained to strict obedience, and to make no suggestions. If the photographer has really got an idea in his head, he had better carry out that idea. Any interference, even from superior intelligence, is sure to go wrong. Some people are wonderfully patient under the application of information; but I confess that I am so peculiarly constituted that the most admirable advice, when I am in the middle of posing a group, quite upsets the ideas I had, and I don't find it possible to adopt those offered. Therefore, from my own experience, I would recommend that, if a friend feels the twitchings of sufficient skill to offer advice, you had better allow your candour to exceed your courtesy, and order him off at once. Two heads, however wise, knocking together produce anything but harmony.

In speaking of my models in what I have written above, I allude to those that have appeared in many of my pictures the last few years. They are not always the same persons; in fact, I get as much change in that respect as possible, to avoid monotony. It is almost as difficult to get variety in dresses as

in persons. I always endeavour to secure a picturesque dress
when I see it. It is not always easy to explain what you
really mean when you meet a girl in a lonely country lane,
and you offer to buy her clothes, but a little perseverance and
a good offer usually succeed. A country girl's dress is not
often worth more than eighteenpence, and if you turn the
pence into shillings, and look business-like all the time, you
may make pretty sure of walking off with the property, or,
at all events, getting it sent to you next day.

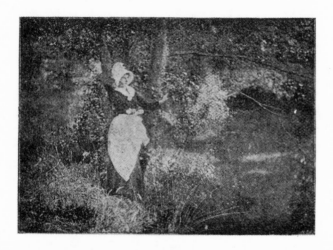

Some models require considerable education, others take to
it at once. One young lady, who had no thought of sitting,
and I no thought of asking her to do so, as she was then
a'most a stranger to me, made one of the best models I ever
photographed. We had no intention of photographing, but
the camera was in the house, and half a dozen plates, and we
had nothing better to do. The first picture she posed for is
represented in the sketch. We had no costumes with us; but
a sun bonnet bought in Regent Street, and intended to be

worn while playing tennis, was as picturesque as one made of calico in the country. A white apron borrowed from a servant, and a handkerchief tied round the neck, transformed the dainty young lady into a comely country maiden. She was posed against a tree by the pond, and told to look a thousand miles away, and think of the future, and the result has been considered a success. The same model half-an-hour afterwards, with very little change of dress, made a very good representation of a Puritan maiden standing by a window in an old oak-panelled room ; and the remaining four plates were used up to like advantage.

Young children make good models; but you must capture them wild. To ask their mothers if you may have them is fatal. They insist on dressing them in their Sunday-school clothes to " have their pictures took." Now a dirty country child is often a delightful lump of picturesque humanity ; but when it is " washed and dressed all in its best," it is about the most priggish bit of nature I know. It loses all its freedom, and becomes stiff and awkward.

Old people are often very useful in landscapes. With them, as with children, you may take the real native. It is between the age of ten and thirty that the genuine peasant is so difficult to manage.

Sometimes a model will suggest a picture. Everybody knows the story of Rejlander and the model for his wonderful " Head of John the Baptist in a Charger." Rejlander saw this head on the shoulders of a gentleman in the town in which he then resided. The curious thing is, that he did not so much see the modern gentleman as always the picture which the head suggested. It was some months before the artist ventured to ask the model to lend his head for his purpose, and years before he obtained his consent. The result, from an art point of view, was splendid, and, considered photographically, a mystery.

One of the best models I ever employed was an old man of seventy-four. He was a crossing-sweeper. I should never have accomplished one of my best works if I had not seen him sitting at a table in my studio, waiting till I could talk to him. I not only saw the old man there, but mentally, the old lady, and the interior of the cottage, although, as it happened, he was sitting before an Italian landscape background. The old man, by his attitude and expression, gave the germ of the idea; the old lady had to be found, and the cottage built, but they appeared to me then quite visibly and solidly. This was the picture called "When the Day's Work is Done." I believe a great many pictures originate in the same way, of which more in the next chapter.

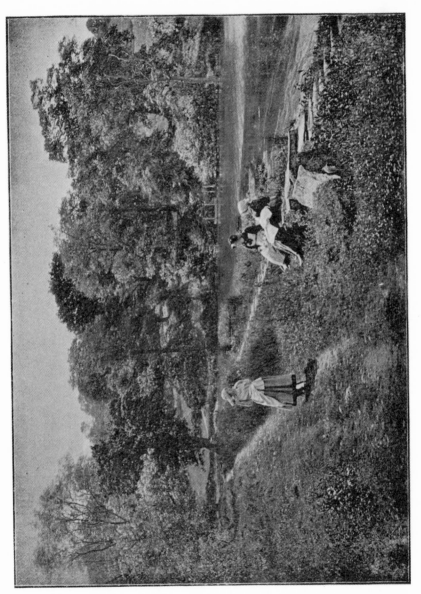

WAYSIDE GOSSIP.

CHAPTER VIII.

THE GENESIS OF A PICTURE.

IT will bring the subject of picture-making more home to the student if I take a picture that has been really done in photography, and describe its life-history from its conception to its realisation in a negative.

And, first of all, how do subjects originate? In great part this question is very difficult to answer. Many of my pictures arise before my mind's eye in a most inexplicable manner, and remain there till I lay the ghosts by making sketches of them. I see these

" Dreams that wave before the half-shut eye,"

absolutely and definitely, and can recall them when I please. They come like a dream, but do not fade away till they are done with. I often try to trace any circumstance that might have given birth to the thought contained in the visual design, but can seldom come to any satisfactory conclusion. But to go much into this part of the subject can have little of interest or use for the student. These visionary images come without rhyme or reason; the designs that will most instruct the learner will be those that come from both these proverbial causes—those, in fact, which have some tangible cause, that can be traced and assigned, for being born.

Most designs obtain their origin from suggestions found in nature. A picturesque bit of landscape will almost certainly suggest to the artistic eye where a figure or figures

should be placed; this will lead on to the questions: What are they to do, how should they do it, and how be dressed? Then the subject ought to appear to the artist, and it will do so if he tries his best to see it, although it might be only a poor or hackneyed one; he will find that experience will improve both the quantity and quality of his ideas. It is astonishing how practice assists the imagination. That art breeds art is a well-known aphorism, and it is as true that subjects breed subjects- The picture you last produced leads up to the next, and the better you make it the better will be those that follow. The student after much practice will find himself half unconsciously storing up hints of wayside beauty and suggestive facts, and composing them in his mind into pictures, always with an eye to their possibility in photography.

In my own practice I never now feel at a loss for a subject. They seem to come naturally when required, but this is the result of experience rather than a natural gift, for I remember many years ago being for a whole twelvemonth without a single idea. Neither could I work up one by any means. I tried every device I could think of. I read a great deal, visited picture galleries, and tried to borrow thoughts from illustrated books, but all to no purpose; no workable idea would arise. I was fallow for about a year, and then the faculty returned, and has always been more or less present. This I put down to constant use, and I mention it for the encouragement of the young beginner, who may occasionally find that his mind is a blank. It would be almost reasonable to suppose that the more of your ideas you used up, the less you would have; but this is not the case. I know this not from my own experience only, but from questioning many artists.

Sometimes incidents you meet with in the streets, or in country walks, will suggest subjects; not necessarily the actual incident one sees, but something that may be worked into some

other scene, with perhaps many alterations. Sometimes a fine
pose may be seen, or a lovely bit of light and shade; sometimes
an expression or a quaint costume; all these things should be
noted for future use. No suggestive bit should be allowed to
escape; all should be sketched or noted. It is good practice
also to try to analyse why the pose is beautiful, or the light
and shade effective. This a knowledge of the rules of light
and shade and composition will enable you to do, and to do
this easily the student will find an added pleasure to his life—
another feather to the wing of his artistic flight.

We will now take a picture that has been really produced
by photography, and see how it was conceived and finished.
To analyse and dissect a picture in a cold-blooded way, as I
am going to do now, is to rob that picture of any poetry it
may contain, and leave nothing but a mechanical interest;
but I know no better means of conveying the information; I
will, therefore, take one of my own—that one I have called
"A Merry Tale" will be suitable for the purpose. The
illustration is a reduction of this picture, and will assist the
reader in understanding what follows.

In the drawing-room of a country house in North Wales
five young ladies in evening costume were amusing themselves
after dinner. One of them was relating some funny circum-
stance to the others, who arranged themselves in a picturesque
group round the story-teller. Here was the germ of the
picture. A few seconds sufficed to make a sketch of the
composition. The illustration is a reproduction of the jotting
in my note-book, and as I have already said, and would enforce,
the practice of making rough sketches of composition and
light and shade is very useful, especially if accompanied by a
few descriptive notes. It teaches the student how to observe,
if it does no other good. Correct drawing is by no means
necessary; the "effect" is what should be noted. To return
to the picture. By an easy transition the mind easily changed

the young ladies into peasant girls, and suggested suitable surroundings. A sketch was made of the arrangement, and the dress for each figure decided on. In selecting the costumes, the light and shade of the group, and its relation to the landscape, were not forgotten, neither were the accessories—the baskets, jug, and stick. The colours were taken into account only as to how they would translate into black and white.

It was arranged that the group should form part of our

work for the next day; but, as often happens in the mountainous districts of Wales, man proposes, and the weather imposes: the morning opened with a deluge of rain, which continued more or less for several days. Those days were not wasted, for young ladies nowadays can not only play tennis, but some of them can shoot and throw the fly, to say nothing of ratting and ferreting! At last the storms were over, and the sun shone again, but with a great deal more wind than a photographer thinks pleasant. However, we determined that we would have some pictures, good or bad, that morning.

We were getting hungry for work, and a conscientious photographer is as anxious to make a good bag as a sportsman, but a photographer's desire for picture-making is nothing to that of a set of really enthusiastic models. Mine, I know, go into the business with the greatest energy. Off we started to a quiet lane about a mile away. The photograph conveys no idea of the picturesque effect of the five girls in their humble but brilliantly-coloured garments. The effect of colours under the green hedgerows and through the fields was quite beautiful. The choruses sung on the way had, perhaps, nothing to do with photography; but the foxgloves and other wild flowers the singers gathered came in very useful in the picture. Arrived at the selected spot, the camera was unpacked, and the models placed approximately in their proper places, interfering branches cut away, and everything got ready, so that the last moments might be devoted to the quite final touches, expressions, and other little things. The sun shone a cold steelly blue, and the wind was so troublesome that we had some thoughts of giving it up after all; but we decided we had taken too much trouble to go home without spoiling, at least, one plate.

Now for the arrangement of the group. The girl to the left was sitting up at first, as will be seen in the sketch, but being a young hand at the business, she could not control herself, and, enjoying the fun, threw herself back on the bank screaming with laughter. This was a happy accident, which much improved the composition, and was seized immediately. She was at once shouted to, to keep her place, which, being an easy one, required little further thought on the part of the photographer, who could now turn his attention to the other figures. The seated figure, the one in the straw hat, was a steady old stager with plenty of experience and no nerves; she required but a moment's attention. The next figure, always dramatic in pose, and with a charming

expression, is, perhaps in consequence of her other good
qualities, rather shaky as a sitter. She required a rest of
some kind. The stick was useful here, and was of immense
value in the composition. A bit of straight line to contrast
a number of curves is always effective. This settled the three
figures that were easiest to keep still. The standing pose
being by far the most difficult to keep—for a standing figure
without a rest often sways like a pendulum—was left until
last. The figure telling the story was now settled; the pose
came easy, the model being an admirable story-teller, and
thoroughly up to her business; but it was necessary to give
all possible effect to the hand, for the hand, if well placed,
would do more towards showing the intention of the picture
than anything else in it. It, in a way, leads the chorus
of expressions. It emphasizes the situation,—it makes you
feel the girl is speaking. It was so arranged that, to make
it more conspicuous, it should appear partly in sunlight and
partly in shadow, and every leaf or twig that came behind
it was hurriedly removed. The standing figure, who could
not be expected to keep the pose for above a minute or two,
was placed last. The jug, basket, and foxgloves, which form
the key-note of the composition in the foreground, had been
previously arranged, and all was ready. But a last glance
from the camera showed the photographer that the tree was
exactly over the head of the standing figure, and cut the
composition into two parts. This would never do. But
instead of moving the model the camera was moved. This
corrected the error to some extent. It would have been
better to have moved it a little further, but it was feared
the other tree would interfere with the story-teller. A few
last words—at the special request of the models I use
fictitious names—" Now, girls, let this be our best picture.
Mabel, scream; Edith, a steady interest in it only for you;
Flo, your happiest laugh; Mary, be sure you don't move your

hand, or all the good expressions will go for nothing; Bee, I will say nothing to you, but leave you to fate. Steady! Done!" and two seconds' exposure settled the matter. I scarcely expected a successful result, the thing was so difficult; but as the wind was blowing almost a gale, I did not care to try another plate. As it happened, I found, when I developed the plate a fortnight afterwards, I had got a good negative. The sky was white and blank; but the use of a second negative, delicate and not too obstrusively printed, soon put this matter to rights.

This seems a long story to tell; but the picture was exposed in under six minutes from the time the models first took their places. This quickness is one of the secrets of success, but when your picture is to include figures it should not have the appearance of hurry, for "hurry hinders haste," and, besides, has the effect of flurrying your models: it should be the result of a perfect knowledge of what you want to do. A model should never be kept waiting longer than is absolutely necessary. It is better to give up little things rather than to lose a fine effect.

CHAPTER IX.

THE ORIGIN OF IDEAS.

NO writer on art, as far as I am aware, has ever ventured to say anything on the question of the conception or origin of subjects for pictures or other works of art. Ruskin, it is true, in his seldom-read second volume of "Modern Painters," treats of the Imaginative Faculty, but in this he soars far above the head of the ordinary reader. The origin of ideas is, perhaps, a metaphysical rather than an artistic matter, and should be left to the writers on what is called "pure reason;" but there is, perhaps, a word or two to be said in connection with the subject that may be appropriate here. New ideas, or what may be supposed to be new ideas, are often thought to be the suggestions of sudden inspiration, but they more ordinarily grow or are evolved from antecedent facts. In the last chapter I showed how a certain picture originated and was carried out. There are many other ways in which ideas may occur. And I must explain before I go on, for fear of misunderstanding, that I am not presumptuous enough to be trying to teach the art of imagination, which is impossible, but how the imagination may be encouraged, stimulated, and strengthened. Some people have a sort of dormant imagination, which only wants waking up to be of great value.

Subjects sometimes start up in the most unexpected manner. I well remember one that occurred a few years ago. We

were walking through an orchard on our way to photograph
a scene that had been previously selected, and had to pass
through a door in a fence into the road. One of my models,
who had a stick in her hand, ran forward to open the door,

and, when it was open, turned round to greet us as we passed,
quoting, laughingly, the old nursery rhyme :—

> " *Open the gate and let her through,*
> *For she is Patty Watty's cow.*"

What a lovely pose she fell naturally into as she spoke! I
give a little illustration of it, but the sketch only faintly

5

recalls the original. The title was, "For the Cows." This must, of course, be secured at once ; no sketching and leaving till another day was admissible. Thanks to the advantages of the gelatine process, and a camera that is ready for action in little more than a minute, an exposure was made before the pose had lost its freshness, or the smile died on the face. But, on the other hand, thanks also to the disadvantages of dry plates as then made, the picture was not good enough to

exhibit ; the emulsion being much thicker on one part of the plate than another, the picture was not quite up to exhibition pitch. The film was uneven *in the wrong place!* These uneven films sometimes give good effects. I once took a medal with a picture that had very little to recommend it to the attention of the judges, except a startling arrangement of chiaroscuro which I attributed entirely to the unevenly coated plate.

In the photograph to which I have just referred, the subject appeared with all its surroundings complete, and did

not require any alteration or correction; but some subjects occur in which the figures are not exactly *in situ*, and these must be treated with thought and judgment. Shortly after the "For the Cows" was taken, I saw the same model on the bank of a stream, shouting to her companions, "Can I jump it?" Here was a subject at once; but the background was ugly and unsuitable. Another was at once hunted up, and found. As it happened, the nook in which the figure appears was inaccessible to the model; she could neither jump the water, nor get to the appointed spot in any unaided way. But a trifle like this should never be allowed to stop enthusiastic photographers. My models and helpers are often more enthusiastic than I am myself. In this case, the helper I had with me picked up the young lady in his arms, and waded across the stream with her.

Adaptation from the works of others is a delicate process which I can only suggest in a very vague way. There are some painters who will copy a photograph and call it their own in the most unblushing manner. Even if that photograph should contain a perfectly original idea, something never thought of before, they will argue—"Oh! it's only an accident in nature the machine has met with; it is impossible for it to be the photographer's own thought—they never think, because they use a machine." But whatever painters may think it right to do in this way, I would caution the photographer to be honest, or, anyway, not to indulge in wholesale robbery. It is not right, for instance, to dress up a figure exactly like a figure in an engraving, give it the same pose, and, in fact, reproduce the engraving as nearly as your means permit, and then exhibit the photograph as your own original thought. On the other hand, I consider it legitimate to "convey" a hint from a painting or engraving. A slight hint may originate a perfectly new design; but it is nothing less than a crime to carry off ideas wholesale and call them your own.

It is difficult to get quite new incidents even in this kaleido-scopic world of ours; and we should find, perhaps, that they would not be understood if we did. Sir Joshua Reynolds said that it is by imitating the inventions of others that we learn to invent. William Morris, in his lectures on "The Lesser Arts," boldly says: "I do not think it too much to say that no man, however original he may be, can sit down to-day and draw the ornament of a cloth, or the form of an ordinary vessel or piece of furniture, that will be other than a develop-ment or a degradation of forms used hundreds of years ago." If Solomon was right that there was nothing new under the sun, nature also teaches us that everything that has the appearance of novelty is not really new, but simply a varia-tion on some previous form evolved from something that has gone before. Evolution, therefore, in picture-making, I hold to be right; but the picture you produce from the germ you have adapted should no more resemble the original in composi-tion or subject than a man resembles a gorilla. There may be a suspicion of likeness; but it should suggest only a far-off relationship.

Anthony Trollope, in his autobiography, tells us that all his plots were of his own devising, except one, which was drawn out for him by his brother. His remarks on originality of subject come in very appositely here. "I mention this particu-larly," he says, "because it was the only occasion on which I had recourse to some other source than my own brains for the thread of a story. How far I may have unconsciously adopted incidents from what I have read,—either from history or from works of imagination,—I do not know. It is beyond question that a man employed as I have been must do so. But when doing it I have not been aware that I have done it. I have never taken another man's work, and deliberately framed my work upon it. I am far from censuring this practice in others. Our greatest masters in works of imagination have obtained

such aid for themselves. Shakespeare dug out of such quarries
wherever he could find them. Ben Jonson, with heavier hand,
built up his structures on his studies of the classics, not think-
ing it beneath him to give, without direct acknowledgment
whole pieces translated both from poets and historians. But
in those days no such acknowledgment was usual. Plagiary
existed, and was very common, but was not known as a sin·
It is different now ; and I think that an author, when he
uses either the words or the plot of another, should own as
much, demanding to be credited with no more of the work
than he has produced."

Then what vast numbers of subjects are to be got from
reading ! I like to reduce all I have said to practice, or to give
a definite example. I will, therefore, take a poem, and
endeavour to show how subjects are suggested by it. I take
Gray's " Elegy in a Country Churchyard," because it is so well
known, and has been so well " worked " by artists.

Twilight has not been much used as a theme for photo-
graphers; yet it is perfectly easy now to produce all the effects
to be noted at the close of day. What could be more sugges-
tive for pictures of this sort than the opening of Gray's poem ?
It is so well known that I will not quote it ; but can anything
be finer or more poetical for a picture than that called up by
the lines—

> " *Now fades the glimmering landscape on the sight,*
> *And all the air a solemn stillness holds.*"

And there is scarcely a bit of country in England that would
not offer materials to illustrate the lines. To London photo-
graphers they are especially available—as, if they want literal
fact, Stoke Pogis, where the poem was written, is within easy
distance, and the actual scenery may be used, especially the
" ivy-mantled tower." But the scene that Gray had before
him when he wrote the poem is not necessary. A prosaic, fact-

giving photograph is not required; the sentiment of the scene is the quality the student must endeavour to secure and represent.

The poem is full of picture-giving lines; some are so plainly descriptive, such as—

> " *The ploughman homeward plods his weary way* "—

as to require no effort of the imagination to see them at once; others are suggestive, and all the more valuable on that account. Of this kind is the line—

> " *Brushing with hasty steps the dews away.*"

In the poem this line applies to a poetic youth, but the artist is not called upon to literally follow the poem; the line itself may be taken without the context, and there are then infinite possibilities in it for other applications—for instance, it would apply to a village maiden skipping along the fields at the break of day, basket on arm or hayrake on shoulder.

Milton's " L'Allegro " and " Il'Penseroso " are also full of lines that ought to wake the student's imagination, and it would be good practice for him to look for pictures with his mind's eye of the scenes suggested. It would also be useful study for him to look over the titles of pictures in an old Academy catalogue, and when he comes to one that strikes his fancy, to endeavour to make a sketch of the composition as it presents itself to his imagination.

I repeat, and insist most strongly, that the best subjects are those that come spontaneously to the well-practised artist, and the suggestions I have made are only intended to show the student how to stimulate and educate his imagination. He must recollect that if, in taking suggestions from the work of others, he does not get very far from the germ of the thought, and if his design is any more like the original than Monmouth was like Macedon, his design is but second-hand; and even supposing the public does not find him out, there will be his own

conscience still left; and if it is anything like a decent con-
science, it will be bad for it to be naunted by the ghost of
plagiarism.

Originality and truth are enjoined in the quaint sonnet by
W. M. Rossetti, which foreshadowed the principles of the Pre-
Raphaelite Brotherhood on the cover of their now very rare
magazine *The Germ,* when they taught English artists to
look to nature, which at the time was in danger of being
forgotten—

> " *When whoso hath a little thought*
> *Will plainly think the thought which is in him—*
> *Not imaging another's bright or dim,*
> *Not mangling with new words what others taught ;*
> *When whoso speaks, from having either sought*
> *Or only found,—will speak, not just to skim*
> *A shallow surface with words made and trim,*
> *But in that very speech the matter brought :*
>
> " *Be not too keen to cry—' So this is all !—*
> *A thing I might myself have thought as well,*
> *But would not say it, for it was not worth !'*
> *Ask : ' Is this truth ? ' For it is still to tell*
> *That, be the theme a point or the whole earth,*
> *Truth is a circle, perhaps, great or small.*"

CHAPTER X.

SUBJECTS.—WHAT IS A LANDSCAPE?

THE variety of subjects open to the landscape photographer is infinite. If he does not find them at his own door, he can find them by the aid of the railway in an hour. The country photographer who knows how to look for them, has seldom far to go for scenes that will supply profitable work for his camera; while his London brother is much better off for landscape themes than he seems inclined to admit. Kent, Surrey, Sussex, Burnham Beeches, and Epping Forest are full of easily-reached beauties, and the Thames itself affords endless variety of splendid scenes—enough, indeed, to last a conscientious photographer his lifetime. The Upper Thames is so full of beauty, that it is now as favourite a resort for artists as Bettws-y-Coed used to be in the days of David Cox. The Lower Thames, with its constantly-changing shipping scenes, is full of picturesque life and animation, and that part of the river which runs through London presents some of the most superbly-composed pictures that could be found anywhere. It is almost impossible to choose a standing-point on the Embankment, or on any of the bridges, from which some picturesque and photographically possible view is not to be seen. The Houses of Parliament, Somerset House, and St. Paul's always compose well, and the atmosphere, almost always grumbled at by the London photographer, appears to me to lend a great charm to the effect. These subjects have never,

as far as I know, been worthily treated. Stereoscopic studies and small pictures have been done; but they have never been used for photographs of any important size. The hay barges, groups of which are nearly always to be seen below London Bridge, would be well worthy of the serious attention of the photographer who wants to exhibit photographs with striking effects. It is not so much that good subjects do not exist everywhere, as that photographers have not trained their eyes and minds to see them.

It is a very curious thing, this art of seeing. In "Pictorial Effect" I gave a chapter on the "Faculty of Artistic Sight;" it will not, therefore, be necessary to go into the subject at any length here. It has been well said that few people see more than five per cent. of what is before them. Some people are contented with little; but others find that the more they learn the more they enjoy. As an illustration, I may quote my own experience in a department of science not connected with photography. Some years ago an entomological friend was visiting me, and innoculated me with the collecting mania. We confined our studies to a section of the British moths, and I was astonished at the world of beauty that was opened to me. I have always been a lover and observer of nature; but, until I made a collection, I had no idea of the number, variety, and surprising beauty of the British moths; in fact, I had never been able before to *see* moths, except the few that committed suicide at night in the gas. The moths are now a source of constant delight to me by day and by night. A new enjoyment was opened to me of which I had hitherto known very little.

The same results will follow, no matter in which direction we turn in our search for objects of study so that we go to nature and learn to *see ;* and the photographer will find that the more knowledge he obtains of what constitutes a picture, the more materials for pictures he will discover. It is true

we cannot always do as we like with our materials ; we cannot always compose our pictures as we could wish. In photography, as a wise man once said, "circumstances govern actions, and play the fool with our intentions," thus making it one of the most difficult of the pictorial arts ; but arrangement and composition, as I have already said, are greatly in the hands of the artist who knows how to use these aids to pictorial art.

There is a good deal of monotony in the subjects chosen by photographers. Nobody seems to have the inclination, or, may be, the power, to break out in a fresh place. It is, perhaps, found to be easier to follow the lead of others than to invent for ourselves. Many subjects are not attempted for fear they should not come out well. They look beautiful in nature, but they do not accord with photographic traditions— they are not like the usual thing. But the photographer should "greatly venture."

> " *He either fears his fate too much,*
> *Or his deserts are small,*
> *Who dares not put it to the touch*
> *To gain or lose it all.*"

Don't be afraid of being original. If you have the least glimmering of an idea that you have a new thought, give it a chance, even if it turns out abortive, for it is not given to everybody to produce a new thing. Don't be afraid if your little bantling of an idea looks different to everything that you have been taught to look upon as orthodox; if there is any real good in it, the strangeness will be part of its merit. A few mechanical defects are easily overlooked, if not applauded. Visitors to exhibitions are as tired of the technical perfections of photography as the Athenians were of hearing Aristides called the Just. Last year I wilfully put a considerable portion of a picture out of focus, which could as easily

have been taken with perfect definition, and it turned out to be one of the most popular I ever did. But I hope this confession will not lead my young readers astray ; it was not the mere fact of part of it being out of focus that made this picture a favourite with the public ; the subject was sufficiently interesting to overpower the technical defect. What you should especially endeavour to avoid is the dead level of respectable mediocrity. Sir Walter Scott, in writing to his publisher about one of his poems, said, " As for what is popular, and what people like, and so forth, it is all a joke. *Be interesting,* and the only difference will be that people will like it so much the better for the novelty of their feelings towards it. Dullness and tameness are the only irreparable faults."

Some photographers estimate the value of their subjects by the amount of difficulty they experience in obtaining them. I once knew a man who cared nothing for the most perfect effects that nature could afford, if they gave him no trouble to reach, and he always went into raptures over an ugly view obtained from an almost inaccessible place, at some risk of his life. This man might have made a respectable athlete, but he was beneath contempt as an artist.

Landscape painters now pay increasing attention to the introduction of figures into their pictures, and it is seldom that landscapes appear at our exhibitions from which human or animal life is altogether excluded. But it is apparently expected to be different in photography, if we are to be ruled by some recent decisions. For some curious reason or other, it has been decided by some judges at exhibitions, that if a landscape contains a figure, it may become a *genre* picture at the discretion of the judges—a not inconvenient way of sorting out the different kinds of pictures to suit different kinds of medals; but it is very puzzling to those to whom the word landscape means a definite kind of picture, even if the term

genre offers considerable latitude as to its meaning. This fancy method of characterizing the kinds of pictures was carried so far at a provincial exhibition, that a medal was actually awarded to " Wayside Gossip " (a picture to which I have already alluded) as a *Genre Portrait!* This, of course, does not make the picture any less a landscape. If the principle of these judges was strictly carried out, we should lose most of our landscape painters. To give only one instance, Linnell's magnificent landscape, " The Disobedient Prophet," in which are introduced some small figures to give the picture a title, would be a " Scripture Piece." Wilson, Gainsborough, Lee, Creswick, Callcott, Turner, and many others in whom we delight as the masters of English landscape art, would have been astonished if they had been told they had been painting *genre* all their lives.

It is seriously argued that if the title of the picture refers to the figures, however small they may be, then the picture is not a landscape. So we must give up Claude, whom all the world has regarded as a landscape painter pure and simple for two hundred and fifty years, as well as those already mentioned, for most of his titles are given by the figures introduced for the purpose, such as " The Marriage of Isaac and Rebecca," " The Death of Procris," and many others. If we want further evidence that a picture may represent an event or incident, and still be a landscape, let us turn to the catalogue of the National Gallery, where we shall find the picture of which I give a sketch on page 34 (Chap. IV.) described thus :—" 61, *Landscape*, supposed to represent the Annunciation, or the Angel appearing to Agar. *Claude Lorraine.*"

Besides those artists I have just mentioned, there are one or two other painters whose works may be taken as models by the photographer who proposes to complete and make his landscapes more interesting by the addition of figures, with the greatest confidence. One of the secrets of the pleasure

conveyed by the works of David Cox consists in the way in which
he always introduced his incidents and figures so naturally,
and so appropriate to the place. There can be no doubt that
the introduction of some incident in a landscape adds vastly to
its interest. Let the picture tell a story, however slight, and
technical defects are forgotten. The scenes of rural life by
Birket Foster, especially his drawings on wood as illustrations
to books, afford grand lessons in the introduction and composi-

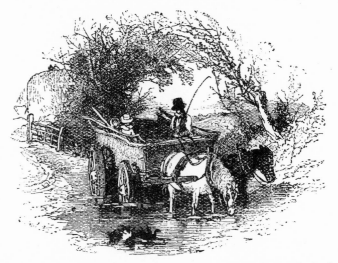

tion of groups of figures, and incidents, and light and shade.
The student will find in these illustrations the great use made
of one artistic expedient, which I have often mentioned, and
which is always successful.

The extreme limits of light and dark are brought together
in small quantities, and the rest of the picture is in demi-tints
and half-tones. If two horses are drawing a cart, as in the
illustration, the one will be black and the other white, and
they will be found to be on the one spot in the picture that
was necessary to be so occupied to pull the whole together. If

cattle are represented in a pool, a white cow will be found opposite to a black one, while none of the others will be found to be quite black or quite white.

In the illustration also notice how the black hat of the man is brought out against the light sky, and the light children contrasted with the dark part of the background. The same principle is carried out even to the ducks in the water.

In conclusion, what photographers want in their subject and their treatment of them, is more originality, more daring, more pluck. We have run in the old grooves long enough, and it is time we took to another line of rails, or retired into a siding.

CHAPTER XI.

A REALLY beautiful landscape photograph, one that is perfectly satisfying to the eye and mind, is very rare. This is an admission I make with the greatest pleasure. So many pictures belong to the dreary order of "might-have-beens;" so many miss by a narrow chance the ray of inspiration that will create a glory even out of an unpromising subject. One of the most depressing of the effects we experience in a photographic exhibition is caused by the prevalence of those pictures which have not quite attained success. Mechanically perfect, clean, sharp, and precise, they lack some subtle quality that is often found in pictures technically poor. Rejlander's works are not yet forgotten, I hope. In them we seldom found one that was from what a photographer would call a good negative, yet, in nearly every picture he produced, there was a something that carried it infinitely beyond the ordinary photograph. It is not easy to define in what respect any particular photograph fails to produce the fullest effect that should have been got out of the subject; but it is easy to see that a great deal more could be done to improve landscape photographs than is done, in a variety of ways, one of the chief of which is, as I am trying to show throughout this book, the proper introduction of figures; and in insisting on this point I shall probably repeat in this chapter the substance of what I have already said; but reiteration may serve to

press the matter more home to the memory, and the examples will make it more clear to the eye.

The first thing that stikes one, as a rule, on looking at one of the ordinary run of landscape photographs is, either that it is very much in want of figures, or that those that are introduced are very much out of place and not adapted to the subject. Perhaps more landscapes are spoilt by the misappropriation of the figures than by the absence of them; but this simply proves that the photographer was wanting in taste or knowledge. But difficult as it necessarily is to get figures that will assimilate with the landscape, they should never be neglected. Landscape without a figure is a suggestion unfulfilled, a fitness unused, an opportunity wasted. The figures should be not only *in* the picture, but *of* it. If more than one is introduced, they should appear to so belong to each other that to separate them would ruin the whole. In a perfect work—a work, however, which I admit is unattainable—it should be impossible to add or to remove from any portion of it. We should, then, aim at producing work that approximates to this condition. If a figure is introduced, it should be felt that this figure gives value to the picture, that it gives importance and support to the composition, and, providing the scene is not of overpowering splendour, that the picture is *made* by the figure. It may look like an accident, but however true it may be that the art should conceal the art, that which to the general public looks like accident should appear to the trained eye as the outcome of deliberate purpose—the result of educated thought, and the expression of subtlest art. A figure, in fact, is often the key-stone of the building upon which the stability of the whole structure depends, and it is this "key-stone" that is almost always taken at random, without any thought or consideration. A figure is too often, indeed, a mere after-thought, struck in at the last moment, and consisting of any material that might be at hand. This

method of proceeding is entirely contrary to what should
constitute good art. Figures should be selected and arranged.
It is often possible to find suitable figures on the spot; but
this is a mere chance to which the photographer should not
subject himself. He may find sailors at the seashore, or
agricultural labourers in a field; but it is much better to make
arrangements with them beforehand; while, for the usual
landscape subjects, it very rarely happens that suitable figures
can be found haphazard. It is much better to take your
models with you, having first paid particular attention to the
dress and general get-up. It should also be decided whether
a dark or a light spot is required in the particular position
in which the figure is to be placed, also whether any story
is to be told, or any title suggested for the picture. Most
commonplace bits of nature can be made to yield pictures
by proper treatment, especially that of light and shade, and
arrangement of figures.

I now propose to give one or two slight examples of how
a subject which would be otherwise uninteresting may be
rendered pictorial by the introduction of a figure or figures.
It is difficult in small wood-cuts or block illustrations to give
an idea of photographs, and, in the present illustration, I
must trust a good deal to the imagination of my readers aided
by description. The subject of the first illustration consists
of a pool of water, with an overgrown hedge-row partially
over-hanging it, and a bit of distance. In itself there was
nothing in this of which a picture could be made; but the
arrangement of the lines, and the breadth of light and shade,
suggested possibilities which should not be neglected. All that
was wanted was a point of interest which would first attract
and gratify the eye, give a meaning to the subject, and collect
together and harmonize the scattered light and shade. It was
obvious that a figure or two would easily do all that was
necessary if they were well placed, and could be made to look

as if they were in their natural and right places. It was not necessary that they should be large (indeed, in this case, I have chosen an example showing how valuable small figures may be), but they must be, above all things, conspicuous. Two figures were therefore chosen, and dressed in the extremes of black and white. They were placed at the balancing point of the angle of the composition, to give it support, and in opposition to the greatest distance, so as to throw it back and

give space. The figures are occupied in "Watching the Newts," which provided a title.

I think I may allow myself here to give the sequel of the story of this picture, although it tells against the photographer, and especially against the maker of the dry plate he used; but it contains, perhaps, as useful a lesson as any other I could give. This photograph never arrived at what might be called exhibition completion. It turned out one of the "might-have-beens," from a different cause to any of those to which I alluded in the commencement of this chapter. The scene was difficult to get at. The subject was a good one, for the

addition of the figures had made it a fine subject. The wind was calm, the light perfect, and yet the photographer confined himself to one shot ! Only one plate was exposed ! He was guilty of that economical folly which should never be allowed to have its miserable way in photography. When the plate was developed, it turned out an exceedingly fine negative, except in one respect, and that one exception was fatal. The plate had been unevenly coated. The film was thicker at one side than the other ; the consequence was, that it developed densely on one side, and was approaching transparency on the other where the film had been thin ; the picture was, therefore, lost.

I will now give an example of how an uninviting bit of coast may be turned to pictorial account by the addition of appropriate figures. This time I have purposely chosen a subject in which the figures are larger, and form a more important part of the composition than in the first illustration. In this case, I give the bit of coast without the figures, in contrast with the completed picture in which the figures are introduced. The subject is that of a girl looking into the basket of a friend who has been shrimping, and asking the question : " What Luck ? "

There is another change that may be introduced with advantage in landscapes, which this illustration suggests. The photographer seldom allows his figures to look larger than pigmies. He seems afraid of a figure of any importance, whether in size or pose. There is no good reason why he should not introduce larger figures with effect. Anyway, there are no technical difficulties to prevent him. The employment of gelatine plates has so reduced the time of exposure that the danger of figures moving is very little indeed, and if the precise photographer insists upon everything being in focus, the quick plates give him the opportunity of using a small diaphragm. Or the resources of combination

printing may be brought to his aid. Double printing is now almost as easy, and as well understood, as any other part of

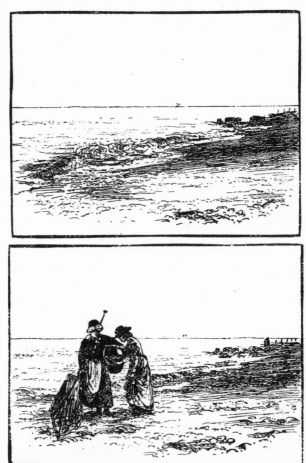

the art. In the photograph from which the illustration was taken, the figures and foreground were taken on one plate, and the sea and sky on another. The departing old man,

whose figure comes in so well in the distance—more visible in
the original photograph than in the sketch—was, I confess,
almost an accident; all I had to do when I saw him moving
off was to be ready to expose the moment he arrived at the
right place. It was the practice with the painters of long
ago to make a great distinction between figure and land-
scape; it was neither a figure picture nor a landscape which
engaged their attention, and, in a limited sense, I agree
with them; but many modern painters—to mention a few,
all of them amongst the most popular artists of the day,
G. D. Leslie, H. S. Marks, Marcus Stone, F. Walker, G.
Mason, and J. R. Reid—have shown us that very charming
pictures may be produced containing important figure subjects,
but in which it has not been necessary to sacrifice the land-
scape. The figures may often be made to tell a story or
illustrate a poem or poetic thought. But the question of
"subjects" has already been considered.

CHAPTER XII.

SUNSHINE.—AN EFFECT OF LIGHT.

IT is the unalterable belief of those whom Shakespeare calls "the general," that the sun takes the picture, a tradition that must have arisen in the early time when photographs were sometimes called sun-pictures, and well deserved the name, for, indeed, in those days, the sun had a good deal to do with the operation. The experimental photographer thought nothing of placing his sitter in the full blaze of the sun for five or ten minutes, and if the victim escaped without having his face white-washed, he was lucky. It was then thought very astonishing that a portrait could be taken in a few minutes, instead of having to give many sittings of long duration to a painter. Improvements in the art have come upon us so gradually that, in talking of it, we are apt to say, "No, there is nothing fresh—nothing particularly new has been discovered," etc.; but if we compare the ill-defined smudge of forty years ago, that required minutes—in some cases, hours—to produce, with the highly elaborate, delicate, and finished result we now get, and that with an exposure made with a flying shutter, because the hand is not quick enough, who shall say we have not advanced? To go still further back. A photograph which hangs over my writing-table—I can see it as I write—must have taken many hours' exposure. I believe it to be the first, or one of the first, photographs ever taken—the minute germ from which such a

vast world has sprung ! It is one of the earliest experiments of Nicèphore Niépce, and was done at Chalons-sur-Saône in 1826.

We have all got into the habit of supposing that photography was invented in or about 1839, simultaneously by Daguerre in France, and Talbot in England; but Daguerreotype was only a development of Niépce's invention, at which he had been at work for many years. But this is a disgression. Let us get into the sunlight.

Some time ago, looking over a dealer's stock, I came to a photograph that quite surprised me. It was of rather large size, about eleven by seven, mounted as a panel on thick board, with gilt edges. It represented a scene in the Highlands—Loch Katrine and the Trossachs, I think, the famous scene described in the "Lady of the Lake." The composition, and light and shade, were quite admirable; but what struck one most was the almost perfect expression of sunshine in it. It absolutely glowed with sunlight ! I do not know the name of the photographer. I was about to ask for it when I was told the price of this lovely print was one and fourpence ! And I felt a sort of instinctive delicacy in asking the name of a man who had the ability to produce such beautiful work and sell it for a few pence. I preferred to think it the production of one of those indifferent photographers who sometimes meet with an accidental success, and trade it off at so much per cent. profit on the materials used, like a baker or a tailor. This little incident set me thinking on the subject, and I came to the conclusion that, although a large majority of out-door photographs are taken in sunlight, very few of them really represent the "merry sunshine," or what has been still more admirably called, "Nature's smile."

There is no doubt that to represent sunshine quite completely, colour is necessary; but the effect of sunlight can be very well suggested without its aid. Turner is famous chiefly

for his colour, but careful study of his works will reveal the perfect subordination of colour to light and shade. This is shown in the fact that all his pictures engrave well. Ruskin, who always preaches colour, in one of his earliest works has shown that colour is not indispensably necessary to the adequate representation of all the phenomena of nature, especially sunshine. Turner, as usual, is his theme. " I have before shown the inferiority and unimportance in nature of colour, as a truth, compared with light and shade. The inferiority is maintained and asserted by all really good works of colour; but most by Turner's, as their colour is most intense. Whatever brilliancy he may choose to assume, is subject to an inviolable law of chiaroscuro, from which there is no appeal. No richness nor depth of tint is considered of value enough to atone for the loss of one particle of arranged light. No brilliancy of hue is permitted to interfere with the depth of a determined shadow. And hence it is that engravings from works far less splendid in colour are often vapid and cold, because the little colour employed has not been rightly based in light and shade. Powerful and captivating and faithful as his colour is, it is the least important of all his excellencies, because it is the least important feature in nature Were it necessary, rather than lose one line of his forms, or one ray of his sunshine, he would, I apprehend, be content to paint in black and white to the end of his life."

How is it, then, that photographs so seldom represent sunlight, when a great artist like Turner would rather give up his colour than lose the sunshine he could always get in black or white ? I suspect it is that we do not give the massing of the light and shade in our pictures sufficient thought. A quantity of flashes and spots of light scattered over the picture will never suggest anything but spots of light; but if a breadth of sunshine can be contrasted with a breadth of shade, but of unequal quantity, sunlight will be suggested, especially

if the composition of the view allows of distinct and vivid cast shadows.

There is another effect of sunlight that has never been well given in a photograph—I mean the effect of passing clouds over a sunlit landscape. To render this effectively, the view must be somewhat extensive, and exposure short. There should be no near foreground, especially of leaves or other objects that would be affected by wind, for the best effects of this kind are accompanied by strong breezes. These subjects are, I know, quite possible. Some time ago I got a capital example of it in North Wales, but the negative was spoiled as a picture by the movement of an ash tree which came rather large in the foreground, and was destroyed at once. I have also found the shadows of clouds on the sea to come very perfectly. In connection with the destroyed negative to which I have just alluded, I may mention that I find it a good plan, when a negative has some radical defect in it, to destroy it at once. If you stop to think, you will persuade yourself to keep, and perhaps print and exhibit, a picture which never should have passed the development stage of existence.

There is yet another effect of sunlight that always has a peculiar fascination for me ; I mean that which is seen in deep woods, especially when there are some grand and hoary trees

> " *Whose antique roots peep out*
> *Upon the brook that brawls along the wood.*"

A broad mass of sunshine falling on the trunk of one of the giants of the forest, contrasted by the deep shadows of the wood, these shadows again relieved by distant trees in sunlight, seldom fails to produce a broad and picturesque effect.

To help photographers to feel how beautiful sunlight really is, I will venture to give a rather long, but most picturesque

quotation from Ruskin's "Modern Painters," a book now almost out of the reach of the ordinary reader. "There is not a stone, not a leaf, not a cloud, over which light is not felt to be actually passing and palpitating before our eyes. There is the motion, the actual wave and radiation of the darted beam; not the dull universal daylight, which falls on the landscape without life, or direction, or speculation,⋅ equal on all things, and dead on all things; but the breathing, animated, exulting light, which feels, and receives, and rejoices, and acts,—which chooses one thing, and rejects another,—which seeks, and finds, and loses again—leaping from rock to rock, from leaf to leaf, from wave to wave—glowing, or flashing, or scintillating according to what it strikes; or, in its holier moods, absorbing and enfolding all things in the deep fulness of its repose, and then again losing itself in bewilderment, and doubt, and dimness,—or perishing and passing away, entangled in drifting mist, or melted into melancholy air, but still,—kindling or declining, sparkling or serene,—it is the living light, which breathes in its deepest, most entranced rest, which sleeps, but never dies."

In looking through a collection of landscape photographs, it will be noticed that nearly all of them are lighted from the side, or with the source of light more or less behind the camera. I know there are exceptions, but few attempts will be found at what is sometimes called "daring" effects. They are all decorously well lighted; but such a thing as a photograph with the sun in front of the camera—in the teeth of the lens—is seldom seen: yet no better opportunity for striking and picturesque effects than this treatment affords exists. I do not mean that the sun should be visible in the picture, although this is not impossible or improper, but that it should be in front—as, for instance, in a sunset. The luminary might be hidden behind a ruin, as in Turner's wonderful "Norham Castle" in the *Liber Studiorum*, or by a tree, as

in many of Turner's and Claude's most successful pictures, or behind a cloud; or it may be so high in the heavens as to be without the field of the picture, but yet have an influence on the clouds and landscapes.

Notice the beautiful perspective effect of long shadows of tall trees as they run from a distance up to your feet. Even ugly nature is sometimes made picturesque and enjoyable by the way the light is thrown upon it. The portraitists have found this out, and applied it in the wrongly-called " Rembrandt " pictures, though they sometimes overdo the effect, not knowing the artistic value of reticence and sacrifice; even the poet has noticed the value of shadow when turned towards the spectator. Everybody must remember the rich attorney's daughter, in Gilbert and Sullivan's opera, who had arrived at a very mature age; the magic of light and shade seemed to make her young again—

> " *You really might take her for forty-three*
> *In the dusk, with the light behind her.*"

In taking pictures with the lens in front or nearly in front of the camera we get the highest light opposed to the strongest dark, a very favourite form of composition among painters, and an excellent expedient for securing powerful effects. By placing the extremes of light and dark in juxtaposition, as I have often had occasion to remark, a key-note is secured which accentuates the mass and contour of the object so relieved in the most powerful way, and gives the utmost limit of effect. By opposing—to borrow an illustration from a sister art—the extremities of the gamut of light and shade, the artist enables the eye to gauge and be sensible of the tenderest tones and semi-tones in other parts of the picture. By bringing the darkest mass of the picture, whether it consists of a boat, or a ruin, or a tree, against the lightest part of the sky, the value of each is enhanced, and a delicate

sense of atmosphere and space is gained that would be difficult to produce by any other device.

It might probably be said that there are great difficulties in the way of obtaining landscape negatives with the lens turned towards the light. Well, there are difficulties. But what photographer. worthy of his camera, objects to difficulties, or would be deterred by them? To me the taking of a subject by photography that presents no difficulties is one of the most tame and insipid ways of passing the time I know. A true musician prefers the violin to the barrel-organ, although it is infinitely easier to grind a tune out of the latter, than to squeak a melody out of the former. Now what are the difficulties that present themselves? The lens, acting as a window as well as a lens, might admit sufficient light to slightly fog the plate; but I do not see any objection to a slight veil over the shadows if the negative prints the effect I require, and a good deal can be done by shading the lens during exposure. There are some photographers who care more about the mechanical or chemical beauty of their negatives than of the pictorial result. They think more of the means than the end. I differ from them. I don't want to preach up the beauty of fog; but I have seen prints from some fogged negatives containing beauties that I don't think could be given by negatives with clear glass in the darks, or any other way.

Another bugbear is halation. This is certainly a very annoying defect; but it is not a fault that cannot be got over. Halation is the result of carelessness. I have never seen it occur, under the most trying circumstances, when the film of gelatine has been thick enough on the glass to give the best results in other ways. I have used some plates that gave this troublesome blurring, but they also gave flat lights and shadows; they would not register nearly all the tones in nature, from the highest light to the deepest dark; both

defects arose from the maker having been too economical with his bromo-gelatine, and the film was thin and blue. Even these plates could be made to give images free—or almost free—from halation, by being properly backed with burnt sienna; but nothing could induce them to give the proper proportions of light and shade.

CHAPTER XIII.

ON SEA AND SHORE.

BEFORE the advent of gelatine plates, photographs of the sea were the unfulfilled dream, rather than the accomplishment, of the photographer. It is true that some very creditable results were produced (chiefly by the aid of double printing), especially for the stereoscope, and, in a few instances, of larger sizes; but nothing to be compared to the marvellous achievements that are now open to the followers of our art.

But with the sea, now we have the means of photographing it, we are doing to-day almost exactly what the earliest photographers did with landscape; we are content to take almost anything that presents itself to us, and think it good if it is sharp. The possibility of getting the tumultuous waves in so short a time that they appear in the print to be quite still, is such a surprise that many photographers appear to be quite satisfied with it, and the simple pleasure of surprise is enough for some people, bearing out the adage " Little things please little minds;" but when the novelty of quickness wears off, they will find there is a good deal more to be done than has yet been accomplished. At present there is too much disposition to rely on accident. A photographer will go down to the sea and fire off some dozens of plates in the hope that a few of them will turn out prizes. This is photographing with the hope of a miracle happening, which I need not say is not art.

In producing plates quick enough to receive the ever-changing, restless sea with ease and certainty, the photographer has had placed in his hand weapons with which he may conquer a new realm. And this addition to his conquests will be fortunately more appreciated in our country than any other, for Englishmen love the sea, and are never happier than when on its surface or its shores. Subjects are more plentiful on sea and shore than in other places. Nearly my first experience with gelatine plates was on the sea, during a yachting cruise on the Clyde and among the Western Islands of Scotland.

Plates and shutters have greatly improved since then; but I was astonished at the wonderful ease with which good negatives could be got even on the unstable base of a yacht in full sail. One of the difficulties was to get the horizon even approximately level. The roll of the boat was not of much consequence, but the pitch, if it happened at the moment of exposure, was often fatal. Recent experiments have convinced me that this difficulty can be modified by using a camera stand with a ball-and-socket joint, with the camera loosely fixed, so that it can be turned about quickly by the hand. With this arrangement, and a finder, combined with a pneumatic exposer, many difficulties disappear. A finder is of great use, for without one the photographer may discover that a vessel has escaped from the field of the picture altogether, or left only her mizen behind her, like little Bopeep's sheep. There are several good finders sold now, but they are most of them too elaborate for my use. I like every piece of apparatus to be as simple as I can get it, and am even prepared to give up some advantages to attain simplicity. The following plan I find to answer sufficiently, and it is always at hand, and never requires separate setting up. The ground glass of my camera is hinged, and when the slide is in, falls flat on the top. On the glass are drawn three lines,

cne directly down the centre, the other two from E to the opposite corners. When the glass is flat on the camera, by placing the eye at E and looking along the central line, as you would along a gun-barrel, you get the centre of the picture, and by looking down the diagonal lines, you find how much will be included in the angle of view. The diagonal lines must be adjusted to the focus of the lens you are using. If the focussing screen does not lie on the top of your camera but falls, as recommended in Chapter II., there will be no difficulty found in making some modification of this arrangement.

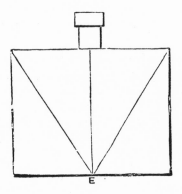

Imaginary lines would be better than nothing. A long focus lens is better for a sea-view than a wide angle.

There are two or three things worth considering in taking ships at sea. I quite believe that all things are possible nowadays, but some are easier than others. A ship going broadside on is more liable to show movement than one coming end on. The cause of this is plain. If a vessel is going parallel with you, it infinitely more quickly exposes fresh sky behind its spars and rigging than does a ship that is coming towards or going from you. The latter covers the same space for a much longer time than does the former, and allows a more prolonged exposure. It is for this reason that photographs of

railway trains going at full speed have been so easy,—they are all taken end on. A vessel sailing in the same direction as yourself will allow of a longer exposure than one that is meeting you, and objects on the deck of the vessel on which your camera is placed will allow of a very prolonged exposure even when the boat is rolling considerably, always making allowance for the jerking of the rigging. It will be found that camera, vessel, and all the objects on it roll together, and, all things being equal, have no effect on the definition. The extra-ordinary photographs of yachts exhibited of late years show that marvellous results have been obtained. The majority of these pictures were taken while racing, from the deck of another vessel. There must have been, of course, many failures in taking these pictures; but much as I object to " flukes," when a photographer produces some hundreds of such pictures as these in a season, I cannot put down success entirely to accident.

But it is on and from the shore,—

> " *Among the waste and lumber of the shore,*
> *Hard coils of cordage, swarthy fishing-nets,*
> *Anchors of rusty fluke, and boats updrawn,*"—

that the photographer ought to expect to find his best subjects. Life on the shore is full of pictures. The sailors and their occupations afford plenty of incidents, while the sands and shingle and cliffs supply picturesque surroundings. There is only one aspect of the sea which defies the cleverest painter or artist of any kind to get anything pictorial out of it, except as a background for figures. A dull smooth sea with nothing on it is the most monotonous, insipid, and characterless thing in nature. It is fortunate that this effect seldom exists for many days together, and the photographer who goes to the sea will find plenty to do, if he has the power of seeing what to do, and knows how to do it.

7

If my reader lives at the seaside, there ought to be little that I can point out to him ; but to the stranger who wants to do real work, I should say select an intelligent boatman, and engage him to carry your camera. Through him you will get to know other sailors. Listen to their yarns and be liberal with tobacco, and you will have a chance of getting pictures that could scarcely be got on any other terms. If you manage them properly, they will become greatly interested in your work, and be always anxious to help, and the assistance they can give is very real. Boats, ropes, lobster pots, and other "common objects of the shore," are heavy to move, and the boatmen are willing helpers, always supposing you get the right side of them. I have known half a dozen sailors work like slaves launching and beaching a great lugger for the benefit of a photographer ; and I must confess, on the other hand, I have seen them very obstructive.

Charming pictures may be made of figures, boats, etc., taken on the beach, using a second negative for the sea and sky. All the precautions necessary for securing truth in a similar kind of picture on land must be more than ever observed in a shore view. The photographer would, of course, not be guilty of the mistake of using a sea and sky lighted from a different direction to that of the foreground ; but there are other things that could scarcely happen inland that must be looked to here.

Suppose, for instance, the subject was a group of figures looking out on a raging sea, it would never do to take the group on a calm day ; the figures would not be in accord with the sea, and it is very possible that there would be included in the foreground objects such a thing as a boat with its sails set to dry, which would of course be torn to ribbons in such a gale as was represented by the sea.

These observations are very commonplace and trite, but it is astonishing how easily obvious blunders will creep into photographs when there is anything but the ordinary thing

done at one exposure. In a late exhibition I noticed several sea views into which the sky had been printed from a separate negative. In these the clouds were seen to go down to and behind the horizon. Now this is an effect that is never seen except in the clearest of latitudes; it occasionally nearly occurs in Cornwall, where the air is sometimes extremely clear, but I have never seen it further North during the observations of many years. There is always sufficient density of atmosphere to give a line of what may be called plain sky for some space above the horizon—that is, between the clouds and the sea.

Many fine pictures can be got of the sea breaking on the shore, from the dash of the giant waves, crashing and smashing themselves into foam on the shingle, to the beautiful effect of long rolling waves creeping slowly over the wet reflecting sand. The chief qualification a photographer requires for taking this kind of picture is presence of mind combined with ready thought, so that he may be able to say at the instant, "This is good!" and pull the trigger; or, "This won't do!" and leave it alone.

The shore is very fertile in suggestions for subjects. The accessories are so picturesque that they call aloud to be photographed, and pictures containing figures can often be snatched with great ease. The photograph from which the illustration is taken was exposed without the little girl knowing anything about it. The camera was focussed on the crab baskets, and the young damsel came to play with them. The elder girl, who had been acting as model in several pictures, at a hint from the photographer, walked quickly to the baskets, stooped down to speak to the child, and, before she could look up, the picture was taken.

To the artist photographer, a fishing village, picturesquely situated between overhanging cliffs, presents dozens of available subjects. The space covered may be small, but the ever-varying

life of the place presents continual change. On the beach the
trawlers may be drawn up high and dry, keeled over on their
sides, the fisher-folk mending their nets, or spreading out their
tanned sails to dry on the shingle, while children swing and
play on the ropes with which the boats are made fast. The
odds and ends of the shore always present opportunities for
groups and single figures of fishermen and girls following their
occupation. The windlasses, piles of lobster pots, creels, bits

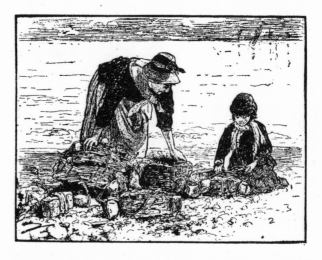

of rope, anchors, barrels, and tar-covered buildings, all suggest
picturesque incident, and dramatic situations. The return of
the fishing fleet is full of lively incidents. Before the boats
get to land, there are always groups of tarpaulined men, with
their wattled creels, waiting to land the cargo. When the
boat, after pausing a moment—a fine opportunity—on the top
of the last wave, is driven straight ashore, she heels over, and
the expecting groups rush to her leeward gunwale to receive
the glistening splashing fish—live soles, giant rays, pollock,
whiting, red gurnard, and perhaps a conger or two. Here is

a picture that could only come to him who knows how to wait, but which happens daily, and is certainly possible.

Then the sale of the fish on the beach by Dutch auction, the removal of the fish to market, or the packing them in boxes or barrels; all these give subjects. So also do the children on the sand; but this is so obvious, and has been so often done, that I will say no more about it.

CHAPTER XIV.

I SHOULD like to begin this chapter with a bold proposition with which some photographers may not entirely agree. It is this: *The beauty of recent photographic landscapes depends in a very great degree on the introduction of skies from separate negatives.*

In the first edition of "Pictorial Effect" I found it necessary to enter into a serious defence of the legitimacy of skies in photographs, expecially when printed from a separate negative. If I attempted to do so now I should only excite laughter, the practice of adding a sky is so universally accepted. The use of anything in photography used to be measured by the possibility of its abuse. The capabilities of any method when in skilled hands were seldom taken into consideration. The question always was: Is it possible for ignorance to go wrong with it? But if we measured every art by the mess that could be made of it by those who not only know no better, but seem to have no capacity for learning better, then no progress would be made in the world. It is pleasant to see a method I have always advocated universally adopted, but it is not so cheerful to see how the blunders that can be made with it still exist. It is pleasant to find that the practice has so far extended that even auctioneers' photographs of houses to let now have their natural skies; but it is vexing to see, as I did this morning at a railway station, a whole collection of these useful photographs with exactly the same sky used for each,

and that without respect to the direction from which the light came. Photography, as I have often remarked, should be confined to the possible. Now I need not explain that it is impossible for the same clouds to exist in the same form in different parts of the earth; that no miracle in nature could produce the same sky effect exactly in separate places or on separate days. But this is not the lowest depth; I have seen in exhibitions photographs ascribed to various photographers, all of them with the same sky! There is no getting away from the fact that these photographers must have each bought their sky negatives, printed them, and unblushingly sent them to the exhibition under their own name! This is artistic immorality.

The sky is the commonest thing we have—it is always with us. It is so familiar to us that we seldom give it more than a passing thought. "It is a strange thing," says the author of "Modern Painters," "how little in general people know about the sky. It is the part in creation in which nature has done more for the sake of pleasing man, more for the sole and evident purpose of talking to him and teaching him, than any other of her works, and it is just the part in which we least attend to her. There are not many of her other works in which some more material or essential purpose than the mere pleasing of man is not answered by every part of their organi-zation; but every essential purpose of the sky might, as far as we know, be answered, if once in three days or thereabouts, a great, ugly, black rain-cloud were brought up over the blue, and everything well-watered, and so all left blue again till next time, with, perhaps, a film of morning or evening mist for dew. And instead of this, there is not a moment of any day of our lives when nature is not producing scene after scene, picture after picture, glory after glory, and working still upon such exquisite and constant principles of the most perfect beauty, that it is quite certain it is all done for us, and intended for our perpetual pleasure. And every man, wherever

placed, however far from other sources of interest or of beauty, has this doing for him constantly."

A good deal that is suggested in the above still remains to be done. There is still room in our exhibitions for pictures in which the sky is made the principal instead of an adjunct This I have mentioned in an earlier chapter; here it only remains for me to suggest to the student what to do, and especially what to avoid.

In many subjects, such as sea views and distant expanses of country, it would be easy to take the sky on the same plate as the landscape, and in sea-scapes it should always be done when fine effects can be secured; but it is seldom that the best pictorial results can be produced by this means. All skies that appear in nature are, of course, to some extent, suitable to the views of which they are the background, but it does not follow that they are always the most picturesque, or conducive to pictorial effect; therefore all I have to say about obtaining the clouds on the same negative as the foreground, which some critics still maintain is the only legitimate way, is, get them if you can, and if the sky and foreground make an agreeable whole, be thankful, and exhibit the picture; but if it is not a pictorial success, then that sky must be sacrificed, and a more suitable one printed in its place. The method of obtaining sky negatives and printing them has been so often described,* that it is not necessary to enter into any details here; but I would recommend the student to always secure a fine or useful sky whenever the chance occurs to him. Never mind whether you see any immediate use for it; make a collection, and they will always be ready to select from. In taking your landscapes, always bear the sky in mind. If not a rule, it was at least a leading direction, with the old landscape painters, that the landscape should fill up one-third or two-fifths of the picture, and the larger proportion be devoted to the sky. This

* See " Silver Printing," by H. P. Robinson and Captain Abney.

will be conspicuously noticeable in the pictures of Wilson, Cuyp, Ruysdael, Hobbema, and others of the old masters; but photographers have found it best to nearly fill their pictures with their subject. The early practitioners were compelled to this, in a manner, by the difficulty of treating the sky, and they got rid of as much as they could of it; but our modern methods have changed all that, and we can represent the sky as perfectly as any other part of nature. Still the practice of crowding the space with the subject by placing the horizon high up in the picture yet survives. Let me recommend the student to try something different. Try a picture over a flat or slightly undulating piece of ground, such as is to be found on almost all of our commons; if you can conveniently get a figure, or a cow, or a sheep, or a cart and horse, to help to make up the picture, turn the camera towards the sun, of course shading the lens from the direct rays, and make a negative occupying about one-third of the plate. You will find that the sunlight, skimming along the upper edges of all the forms, produces a good and novel effect. Print this negative rather dark, filling the other two-thirds of the picture with a sky negative taken under the same conditions, but not necessarily at the same time, and if everything has been done well, you will find you have got a fine effect. I have recommended you in your first attempt to turn your camera to the sun, because the clouds in that position are often very beautiful in form, and strong in light and shade, and therefore more easy to photograph; but it will, of course, be understood that the sky is possible and generally beautiful in any of its phases as regards the sun, from morning to twilight. There are a few precautions that must be observed. The light must always fall on the clouds from the same direction that it falls on the landscape. Nothing could be more incongruous than a foreground lighted from the right, and the sky illuminated from the left. It is these departures from truth that bring discredit

on our art. The sky should belong in character to the land-scape, and should agree with and not fight against the view. If the objects in the view are important, the sky should be kept quiet; but if the subject is some very bold or striking cloud, then the landscape should be kept subordinate.

The state and character of clouds vary with the altitude at which they are formed. The visible sky consists of a graduated series of systematic forms of cloud, each of which has its own region and specific character.

Skies taken high up or looking towards the zenith should never be used near the horizon. Besides the variation in shape of clouds at different altitudes, they alter greatly according to their position in the sky; this is due to the effect of perspective; and there are some clouds, such as the cirrus, that are never seen except high in the heavens. Well-defined clouds are seldom or never seen near a low horizon: this is especially noticeable over the sea.

Cloud forms are of great use in aiding and correcting com-position. The great variety of lines and forms and masses of light and shade to be found in a good collection of sky negatives ought to enable the photographer to produce presentable results out of indifferent landscape materials. It sometimes occurs that the lines of composition in a scene are not what an artist would wish, and that no attention to point of view will materially improve the arrangement. A picture of this kind may be saved by the right use of a sky. Opposing lines may be introduced, and balance restored. Constable, who made sky painting one of his chief studies, wrote to a friend: "That landscape painter who does not make his sky a very material part of his composition neglects to avail himself of one of his greatest aids. I have often been advised to consider my sky as a white sheet thrown behind the objects! Certainly, if the sky is obtrusive, it is bad; but if it is evaded, it is worse. It will be difficult to name a class of landscape in which the sky

is not the key-note, the standard of scale, and the chief organ of sentiment."

All this must be done with knowledge. This knowledge will come easy to the observing student, but it must be a knowledge of nature as well as of art. I hold it legitimate for the photographer to produce his effects by any means so that they are so true to nature that experts in nature shall not be able to deny their truth.

CHAPTER XV.

ANIMALS.

WHEN Landseer asked Sydney Smith—to whom all witty sayings are attributed—to sit to him for a portrait, the Canon of St. Paul's replied: "Is thy servant a dog, that he should do this thing?" A fair suggestion that a great animal painter may not be able to render the human face divine. Will the time ever come when the several branches of photography shall have their distinct professors? Will the landscape man ever boast that he can also photograph the figure, as some landscape painters now pride themselves on their drawing of the human form, as something exceptional? Will the portrait photographer ever find himself so entranced by his portion of the art that he can never find time to do a bit of landscape or architecture? If ever any student of our art finds himself compelled to confine himself to one department, it will be the animal photographer. Just as Mark Twain says, there is more *to* a blue jay than any other bird, so there is more *to* animals, from a photographic point of view, than all the rest of creation. If you want to get the best results, you must make a more minute study of your "sitters" than is necessary even with the superior animal—man. You cannot expect to get the best expression out of a Scotch terrier at your first enterview, or the amiable purr of a cat at an early acquaintance. Sir Joshua Reynolds found it of great assistance to him in getting the best and most characteristic portraits of his sitters, to dine and spend the evening with them ; so with

what we complimentarily call the brute creation, we cannot expect to get the best results if we come upon them, camera in hand, as total strangers.

There are few animals that cannot be photographed, as Mr. York and Mr. Dixon have shown in their marvellous pictures of animals taken in the Zoological Gardens; but it is not of " wild beasts " that I have anything to say here. It is the domestic animal that is more likely to engage the attention of those for whom I write. Infinite care and patience are required to photograph animals; but some are much more difficult than others. It is seldom, for instance, that a cat will allow herself to be approached by a stranger on photo-graphic thoughts intent; while it is imagining a vain thing to take her to the studio or other strange place for the purpose of having her portrait taken. Of all the domestic animals, the cat insists most on having an " At Home " portrait. The dog is different. He does not care where he has his portrait taken so that it is done in the least possible time, and without much fuss. The large dogs, as a rule, take it in a lazy, contemplative manner; while the small dogs—by far the most difficult—seem to want to know all about it, and are not easily controlled or kept within range of the focus. It is difficult in writing to give any suggestions about the management of any animals " under the lens ; " but you may take it as a rule that violent noises used to attract the attention of dogs will have a contrary effect to the one intended. A quiet little noise with the mouth, scratching a paper, or gentle rapping out of sight, will almost always make a dog look up; indeed, it is scarcely too much to say that expression may be controlled by these or similar means; while everybody knows the exciting influence of the word "rats" on dogs of the terrier kind. But this should always be kept as a last resource, for no well-educated terrier can sit still for long, however obedient he may be, when he hears the word "rats" whispered even in the gentlest tone.

A panting dog is always a nuisance to the photographer. This difficulty may sometimes be removed by a drink; but the water should be given just before the exposure is to take place, for the effect soon wears off. It may be partly checked by keeping the dog from running about for some time before the operation. Very much more characteristic pictures of dogs ought to be got now we can take snap shots at them than in the olden times.

Of all animals taken to the photographer the horse is the most frequent. Everybody who owns a horse thinks it the best horse of the kind ever invented, and wants its portrait. It is fortunate that he is a good sitter. The photographer has nothing to do but to see that the position is easy—for even horses can pose—and that the expression is bright. A horse cannot smile, but he can do a good deal in the way of expression with his ears and the pose of the head. The one thing to look out for is, if possible, to get the four legs to show. It often happens that the two near legs hide the other two, and the horse looks as if he were standing on two pegs. A horse standing so is exceedingly ugly; but there is a fashion even in the way horses stand, and I lately refused to photograph a lady on horseback because her groom insisted that the horse should stand with the legs level, and stuck out at both ends of the animal in the fashionable way.

Horses are easily kept still. They will prick up their ears and listen to a noise—either the shaking of a newspaper or a whistle—for almost any length of exposure. There are some fidgety horses that nothing will keep quiet, but, fortunately, they are not numerous. Many will champ the bit unceasingly; but this can sometimes be prevented by loosening the curb. The real worry comes from the incessant whisking of the tail in hot weather, when flies are troublesome. The only way to get over this is to take the horse on a cool and cloudy day. If a portrait of the horse is required, it is much better to do it

out of the sun. The violent light and shade of sunshine is apt to spoil the likeness.

With the painter, cattle-pieces have always been favourites. The names of Cuyp, Paul Potter, Ward, and Cooper recall triumphs in cattle-painting in generations that are past or passing; while the modern school, so different from its predecessors as to be almost a new art, has its constant admirers. But by whatever school they are produced, pictures containing cattle and sheep will always find favour with the country-loving English people. Now I do not know that photographers have yet offered to the public anything very admirable in the way of cattle-pieces. If they have been produced, they have certainly not appeared in our exhibitions. Mr. Berkeley has shown us in one little gem, which he called "Noon," a perfect group of cattle in a stream; Mr. Gale has turned agricultural horses to good pictorial account, and a few sheep are found occasionally in landscapes; but the great cattle photographer has not yet arisen. Capital pictures could be obtained: the things required being opportunity, patience, and skill. The photographer who wants to succeed must make his opportunities, and he possesses the two other qualifications, or he is not in a state to gain much advantage from reading this book. A fortnight's residence at a farmhouse ought to put many fine subjects in the student's way. Milking-time is always a good subject, one that comes ever fresh, however treated. "Feeding" is a theme that always supplies food for the artist. Feeding cattle—feeding pigs—feeding sheep (a splendid snow subject) feeding chickens—feeding pigeons, ducks, and geese; there is no end to the opportunities these operations afford.

In taking such photographs of animals as are here suggested, don't forget that your object is not so much to get a portrait of a difficult subject, as to make a picture. There are some who think that if they succeed in getting the beast still, they have done all that is proposed; but this is only a very minor

detail—there is composition, light and shade, and all that goes to make a picture, to be considered. A group of sheep in a level meadow lighted flatly from the front, would be worthless as a picture; while the same sheep viewed from the other side, with the light just edging their backs, might be very picturesque. Sheep are easily managed, and very useful in a landscape. If a group are lying in a row, or in positions that do not "compose," walking a few steps towards them will induce a few to rise and look about, giving the photographer

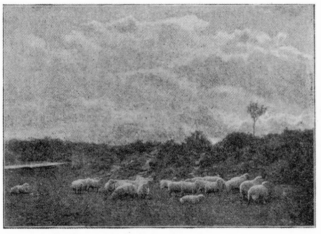

"IS IT A DOG?"

the effect he wants. If they are inclined to straggle and escape, a judicious assistant, by quietly walking round them, can easily induce the group to remain, while the imitation of the bark of a dog, or a whistle, will quickly produce life and expression without frightening them away. The illustration, "Is it a Dog?" was taken in this way. Cows, when in the open, are rather more difficult to manage. They are given to bolting; but are not entirely unmanageable. But whether easy to get at or difficult, refrain from exposing the plate if the "effect" is not good—the world is already flooded with indifferent photographs.

CHAPTER XVI.

OLD CLO'.

THE student should never omit to pick up quaint and picturesque bits of costume whenever he has the opportunity of doing so. Aladdin's enemy, the African magician, offered new lamps in exchange for old; the modern magician, who evolves pictures by another kind of magic, may do worse than follow the example of his African brother. I am sometimes tempted to trade in the same, apparently, insane manner, and give a new frock in barter for a weather-stained old garment not intrinsically worth tenpence. It is curiously difficult to meet with anything strikingly picturesque and suitable in the way of costume, and still more difficult to secure it. The wearers at first think you are making fun of them, and end by thinking there is something more in it than meets the eye, and that they ought to have made a better bargain. It took an artist friend of mine some hours and a long journey to buy a navvy's waistcoat. The garment is a perfect treasure to a painter, but not of so much use to a photographer, for its virtue lies in colour. It was originally a blue velveteen, but had become worn and weather-stained into a lovely harmony in blue and green. My friend was coming on a visit to me at Tunbridge Wells, and saw the possessor of the wonderful waistcoat on the platform at Charing Cross Station. He followed him into a "third-class smoking," got into conversation, plied him with tobacco, and after a lot of diplomatic talk, offered to buy the coveted garment. The thing was not worth eighteenpence, but my

8

friend offered seven-and-six. The navvy thought he had met
a fool or a millionaire, or perhaps both in one, and refused to
sell at any price. Tunbridge Wells Station was reached, and
the bargain not concluded. The painter ought to have got out
here, but the waistcoat was too tempting, and he went on to Hast-
ings with the navvy, where he at last managed to arrange a deal.

An artist, who built himself a " lordly pleasure house " in
the country, gave every old woman—and young one, too—in
the parish a red cloak, that the spots of bright colour should
add a charm to the landscape. Not knowing their origin,
I once tried to buy one of these cloaks, and then I learnt the
mystery that had puzzled as well as pleased me. The village
was not entirely inhabited by descendants of Red Riding Hood,
neither had the fashion of that particular cloak descended from
generation to generation, like the tall Welsh hat, which
descends as an heir-loom from mother to daughter in the
Principality. It was a happy thought : but there was one
defect—the cloaks were all alike in cut and colour ; there was
no variety. Now, what the student should aim at in the
collection of a rustic wardrobe for photographic purposes is
not only picturesqueness, but variety. It is more difficult
than would be supposed to get what might be called, prosai-
cally, a " change of clothes " for your models. And if you
have collected a great variety, you have a predilection for
certain dresses and effects, and they insist upon coming in like
the much-quoted King Charles's head in Mr. Dick's " Memorial."
I am painfully conscious that I fail in this way as much as
anybody. There is a particular way of arranging one of the
articles of rustic dress I so often adopt that my artist-friends
call it my trademark. I do not mean to point out what
it is more particularly, for I don't want to make it more
conspicuous, and I am sure I shall want to use it again.

The dresses need not be the unsophisticated bits of drapery
they appear to be in the finished picture. There is no reason
in the world why a white apron or handkerchief should be

absolutely white in the original, when they would give nothing
like so pleasing an effect, and photograph much worse than
if they had been dipped in a weak solution of coffee or
" Judson." In addition to dresses, cloaks, aprons, handker-
chiefs, and the like, great variety of effect can be got out of
hats and bonnets. There are marvellously picturesque shapes
in straw to be picked up for a few pence ; those introduced a few
years ago, called, I think, Zulu hats, sold at about twopence
each, added a new beauty to rustic life. But it is the sun-bonnet
that is characteristic of the country. This is made in every
variety of shape and colour. Sometimes a light one is useful to
come out as a light spot against a dark background ; sometimes
a bit of dark is required to contrast with a brilliant light.

In dressing your figures, let there be no mistake ; your
figures must be so like the real thing that only the initiated
shall discover the difference. Fancy dresses won't do. Corydon
and Phyllis fresh from a costume ball may be very well as
china ornaments, or on the stage, but they would be out of
place in an English landscape. Shepherds and shepherdesses
with pet lamps and crooks, and aristocratic milkmaids,
belonged to a time when art and literature were in their most
debased and artificial state, and should never be revived except
in burlesque. I am the more particular in insisting on this
because I cannot help noticing that when attempts are made
to make the kind of pictures I have been writing about,
there is usually a dressed-up look about the figures. This is
not the fault of the art, but of the artist.

Besides dresses, and all that belongs to dress, a collection
of accessories should be got together, such as baskets, jugs,
sticks, hay-rakes, and the numerous little things that are to
be met with in country life likely to give a motive for a picture.

If sea-pictures are your object, it is always well to have
accessories, such as shrimping-nets, lobster-pots, etc., of your
own ; you are then independent, and it is not always possible
to borrow just at the time you most want them. When people

are busy they cannot always, however willing, lend the tools they are working with. If you go into a hayfield to make pictures, weather, wind, light, and all that goes to make a picture, may be right, but haymaking while the sun shines is a thing about which, proverbially, it is dangerous to have any delay, and the haymakers may be too busy to attend to you or lend you their implements; if you take your own models and everything they require, you will be able to give time to your pictures, and may expect good results.

There is another aspect of the costume question which may be referred to here. Scenes and incidents of country life seem to be better adapted to the requirements of the photographer than any other kind of subject, especially if he should intend to make a point of his figures. There are, however, subjects sometimes attempted that seem quite unsuitable to the art. We are bound to recognize ordinary facts, and should keep within the possible. An anachronism should never be allowed. The photographer should accept the limitations to which his art confines him, and only represent those scenes and subjects which could exist in the nature of his own day. To dress a figure in the costume of past times, and to call the photograph of it by the name of some historical person, is to commit an anachronism. In painting it is different. Although the painter uses a model, he does not give you, or pretend to give you, an exact portrait of his model. You do not think of how it is done when you look at the painting, but you can scarcely escape the feeling that a photograph is the absolute reproduction of some scene or person that has appeared before the camera. I have seen a photograph, for instance, entitled "Sir Roger de Coverley." We all know that it is not the Sir Roger of the *Spectator*, but a portrait of Mr. Blank dressed more or less like the real old country gentleman. There would have been no objection to calling this picture "Mr. Blank as Sir Roger de Coverley." In the early part of my photographic

career, I was as much a sinner in this way as anybody. I
didn't know better. I did not hesitate to call my little efforts
by the names of people who had died a thousand years before
photography was thought of, or who never had any existence
at all. Ophelia, Elaine, Mariana, the Lady of Shallott—these
were some of the names I profaned. I soon found out my
mistake. I am not one of those who pretend not to read or
take heed of criticisms, and have often felt obliged to the
critics for many a hint. The following from a notice of
the Exhibition, 1859, in a morning paper, is what opened my
eyes on the subject. It is curious to read, after so many years,
that my first success was as popular as a nigger melody—
although not a dozen copies were sold, and it only appeared
at two London Exhibitions.

" We do not say that a great many new photographs have not been
collected, but simply that there are far too many old ones. Why, for
instance, are we to be followed everywhere by the eternal ' Fading
Away,' which is fast becoming as great a torment as a popular nigger
melody, or any other fashionable street tune ? If Mr. Robinson wished
to give the public some specimens of his supposed skill in treating
dramatic and poetic subjects, surely he could have thought of some
novel scenes. We are not sure that Mr. Robinson's figure of ' Mariana '
is not new, but we are quite certain that it will not suggest to any one
the ' Mariana ' of Tennyson. It is simply the portrait of a young lady
trying to look like ' Mariana,' and not succeeding. Choloponin, a Russian
photographer, has sent, among other things, a figure of ' Mdlle. Orecchia
as Leonora,' in the ' Trovatore,' which is satisfactory in all respects. If
Mr. Robinson had been the producer of this photograph, he would, in
accordance with his system, have entitled it simply ' Leonora.' "

I accepted the critic's hint at once, and have never since
given any of my figures the names of historical personages.
But the particular is not the general, and I see no objection
to the use of well-known names, such as Clarissa or Rosalind,
for a picture, so that it is not intended that the picture should
represent any particular persons, such, for instance, as the
Clarissa of Richardson, or the Rosalind of Shakespeare.

CHAPTER XVII.

PREVIOUS to the advent of gelatine emulsion plates— the marvellous rapidity of which enables the photographer to succeed easily with subjects and under circumstances hitherto deemed impossible—"portraiture without a studio" would simply mean taking portraits out of doors, with all the manifest inconveniences and discomforts such conditions imply; but now that more rapid plates have rendered brilliant illumination unnecessary, portraits can be easily taken in a room, the only light required being that of an ordinary window. Nor need the results be in any way inferior to those taken in the best appointed studio—indeed, I have seen portraits and groups taken in a room that were superior to much of what is called "the best work;" one of the reasons for this superiority being, perhaps, that they were less conventional than the usual studio pictures.

There is another reason why satisfactory results can be obtained in an ordinary room—there has been a great improvement in taste of late years. A greater variety of lighting is now allowable than in the early days of photography, when the head was expected to be nearly evenly lighted, enough shade only being admissible to give relief and roundness; and a flat, plain background was imperative. It used to be an axiom with some photographers that if there was a spot of high light on the forehead and down the nose the lighting

was right, and every other quality was sacrificed to this curious notion. Now, anything is permitted, and, if well done, admired, however it is lighted, whether the face is full of delicate gradations, or nearly black, as in some exaggerated so-called Rembrandt effects. Let us now consider the various kinds of effects that can be produced in this manner.

Perhaps the easiest kind of portrait to take by the light of an ordinary window is that in which the head and shoulders only appear. It frequently happens that sufficient space cannot be obtained to enable the camera to be placed far enough from the sitter to include a full-length or three-quarter figure; a head, then, is all that is possible. The best kind of room for our purpose is one with a large window on one side, and a smaller one at right angles with it. In a room of this kind it is almost impossible to light the head ineffectively. The sitter should be placed near the large window, and the blind of the small one should be so arranged as to admit sufficient light to soften the shadows. It will be found that almost any modification of light and shade can be obtained by this arrangement. When the use of a second window is not to be had, the shadowed side of the face may be much softened by the aid of reflectors; an efficient and easily-managed reflector may be improvised with a clothes-horse and a sheet, or with a screen covered with white cloths or paper. Another method of getting a delicately lighted head without the use of reflectors would be to place the sitter in a room at a distance of ten or twelve feet from the source of light, and place the camera near the window, looking across the room diagonally at the subject.

Bold and startling effects of light and shade are perhaps more easily to be obtained in a room than in a studio, and often suggest themselves. Rembrandt effects, and all kinds of shadow pictures, are not only possible, but can be produced with very little trouble, care being taken in turning the lens—

as will be necessary for shadow portraits—towards the window, to protect it as much as possible from the direct rays of light, especially when very sensitive plates are employed; it must always be remembered that the lens acts to some extent as a window, as well as a condenser and refractor.

When the room is large enough there is no reason why very effective groups may not be made. A group of figures sitting in a room at their various occupations would be much more natural and pleasing than the usual pile of people, which seems to be nearly the only way in which photographers can arrange several people together. I don't say there should be no arrangement; I don't believe in anything being successful when done in a haphazard way; but there is more scope for natural arrangement in a room than before a six or eight-feet background. Neither with gelatine plates should there be the usual difficulty about getting all the figures into focus. It is not at all necessary to use a portrait lens of wide aperture for the sake of getting all the light possible. It will be found that landscape lenses, or such a lens as the rapid rectilinear, will afford a sufficiently short exposure, and will cover the plate without confining the focus to one plane.

In indoor portraiture it will be often found that the natural background will be the best; but one or two things should be avoided, and others it should be the object of the photographer to obtain. All spotty lights and patches should be avoided. For instance, a framed engraving with broad white margin would have a very distracting effect if it came behind the head, so also would a white marble chimney-piece, or a shelf containing porcelain; but if any of these could be shaded and subdued there would be no objection to them; variety of form and tone in the background give a great charm to the picture.

Many of the new wall-papers make good backgrounds, but violent patterns should be avoided. There should be nothing

loud in composition or chiaroscuro. A knowledge of art has
become so general amongst photographers that it is perhaps
unnecessary for me to insist so strongly on these things; I will
therefore only say that the endeavour should be to avoid
flatness, and to produce a variety of light and shade behind
the head. Nothing has a better effect or gives so much relief
as a background that comes dark behind the lighted side of
the head, and light behind the shadowed side. An effect of
this kind is easily produced in the following way.

A simple two-leaf screen is placed behind the sitter; the
light from the window falls on the leaf behind the shaded side
of the head, leaving the other leaf in dark shadow. This is
the best make-shift arrangement I know; but there can be
no doubt that a properly painted and graduated background is
better than any other contrivance that can be devised, because
it enables the photographer to place his light and shade
exactly where it best suits his endeavours to get breadth and
pictorial effect.

CHAPTER XVIII.

INSTANTANEOUS PHOTOGRAPHY AND THE PERSISTENCE OF VISION.

IT has long been felt by artists that there is "something wrong about instantaneous photographs." Moving objects do not appear to move; the sea is frozen; the express train stands still; figures of men and animals seem to have been caught unawares in awkward postures, such as are never seen in nature, and stiffened in their tracks; like the *Sleeping Beauty*—only they are not beautiful—they are fast asleep. The difference in effect between what is and what ought to be will be best felt on comparing a painting of the waves by our greatest marine painter, Henry Moore, A.R.A., with a photograph of the sea exposed with the aid of one of the remarkable pieces of mechanism supplied to photographers for the purpose of annihilating time. Unfortunately there are photographers to whom it is useless to talk about the "feeling" of a picture. Everything must be proved scientifically, therefore I will try to bring in a bit of science before I conclude, even if I have to borrow it.

One morning in November I received this telegram from a Deal boatman :—"Blowing whole living gale; business expected. Jack." I did not like to lose the chance of photographing a wreck and started off at once, but was too late. The gale had blown itself out more quickly than was expected, and there was no improvement in "business" for the boat-

men; there were no wrecks on the shore, nor vessels in diffi-
culties on the Goodwin Sands; few ships in the Downs, for the
wind was still east, and it is the west wind that drives vessels
for shelter; no visitors in the town; nothing on the beach and
sea but boats and gulls. I was told that an east wind had
nine lives, and that things might mend; and Deal has a sort
of prescriptive right to a good proportion of the wrecks that
occur on our coasts. " Deal has been very unlucky this year,"
said my boatman; " how is a poor fellow to keep his wife and
family if there are no wrecks? besides, the nasty steam-tugs
take such a lot out of our mouths; steam is spoiling the
business." Still nothing on the bleak shore and uninteresting
sea but boats and boatmen and gulls.

The gulls have always been a fascinating study to me.
Photographers of pre-historic times—say twenty years ago—
may remember a picture I exhibited of seagulls, and what a
prolonged and sometimes angry controversy there was on the
question, " How is it done?" That dreary question, which
takes all the life and soul (if it have any) out of a picture
which has the poor ambition of *being* a picture and not a
sample of a process. Amateurs ask what process, and especi-
ally what lens and shutter, and when they are told think they
know all about the picture to its innermost depths.

It is high time we left off labelling our pictures with the
names of the processes by which they are done. Exhibitions
consist principally of pictorial results, or attempted pictorial
results, produced by the agency of photography, and that they
are by photography should be sufficient description. If
anybody has a new process to show, or, as is more usual, some
modification of an old one, let him show his samples and
describe them; they are the other side of the matter.

But let us return to our gulls.

I remembered a photograph—done at Southport, I think—
of a large flock of gulls, taken so quickly as to show the details

of the birds. Many of these gulls did not seem to me to be true representations of the natural gull as it appeared to my eyes, indeed, no truer than the remarkable instantaneous photographs of trotting horses and other animals that have been shown as the real thing. Some of the gulls, especially those hovering or on the turn, appeared true enough, but there was one particular bird, flying at right angles to the spectator, which had its wings hanging down, and there was no show of any part of the wing above. At Deal I made careful observations of gulls flying in this direction, and could not detect one with the line of the back against the sky quite clear of wing. One day a crow flew past, and being black, was very favourable for observation. Any one seeing that bird for the first time, without knowledge of what a bird was, would have said that it had four wings instead of two only. This optical illusion is, of course, easily accounted for scientifically. The statement of the cause is so clearly given in Lee's "Handbook on Light" that I cannot do better than quote it:

"The impression which light makes on the eye is not obliterated *instantaneously*; it continues for a short time after the cause of the impression has ceased to act. Its duration is found to vary with different eyes, and also with the intensity and colour of the light; but, in all cases, its amount is a sensible fraction of a second. If, therefore, a series of distinct impressions be made upon the eye, which succeed each other with sufficient rapidity, these impressions will be blended together, and will produce a continuous sensation. This persistence of impression explains the following familiar facts: The glowing end of a stick which has been thrust into the fire, when whirled rapidly round, gives the appearance of a continuous circle of light. A flash of lightning is seen for a time as an unbroken track of fire in the heavens. A falling star presents a similar appearance. So, also, when it is raining heavy, there appear so many lines of water falling to the ground."

It, therefore, follows that a photograph of moving objects, taken in less than the fraction of a second, during which impressions remain on the retina, may represent a scientific fact,

but is not true to nature as we see it, for it represents that which the eye has never seen, nor ever will see. Yet ignorant writers who pretend to science turn to these misleading photographs, and point them out to artists as proofs that what they call their " conventional representations " are all wrong, forgetting that the eye of the camera is not the eye of man.

It will be only necessary to carry the absurdity a step further and photograph a stationary spark and call it a flash of lightning. If we could make the process and shutters quick enough to perform the feat (and the inconceivable is not the impossible, as some people think), a flash of lightning would be so represented, for a flash occupies the time which it takes an electric spark to travel from one place to another, and its appearing as a zigzaging, quivering length of fire is due entirely to the persistence of the impression on the retina of the eye.

The question is, Are we to say that everything which is not scientifically true is fiction? It is not true that the flash of lightning is a streak of fire, yet it appears to be so, and that should be quite sufficient for artistic purposes, and to represent it as we do not see it would be artistic falsehood. Minds of the imperfectly cultivated sort take delight in proving others to be wrong, and paradoxes commend themselves to the feeble-minded more from their semblance of subtlety and depth than for any other reason. Truth really is not their real objective. But I do not wish it to be understood that very quick exposures should not sometimes be used; there are many subjects that may be taken in much less than the tenth of a second, or even a hundredth, without violating truth, and the quickening of the sensitive plate was one of the greatest boons ever conferred on the photographer. It is the abuse of the process of which I complain, and especially of having these photographs, taken under conditions which represent nature as we never see it (very interesting, no doubt, from a scientific point of view),

held up as models of truth, and as convincing evidence that artists of all ages have been blind and knew nothing of the nature which it is the object of the artist's life to study.

Notwithstanding what I have just said about paradoxes, I must use a sentence which looks very like one. It is this. The nearest road to truth is by way of fiction. It is acknowledged by everybody that no writer ever approached so near to the truths of nature as Shakespeare did, yet nobody can accuse him of being an apostle of scientific fact. He always showed the greatest contempt for facts. It was not through ignorance that he fired cannon in Hamlet's time, or made Cleopatra play at billiards.

CHAPTER XIX.

STRONG AND WEAK POINTS OF A PICTURE

HOWARD, in his "Sketcher's Manual," gives a curious chapter on the strong and weak points of a picture. I have already pointed out that the centre is the weakest part. The following notes on the subject may interest the student, and be of use to him in the arrangement of his compositions.

"The feeble points are those which are at an equal distance from any two of the boundary lines, or corners of the picture.

"The strong points are those which are at unequal distances from all the boundary lines and corners.

"Any point that appears to be at an equal distance from one corner or boundary line, whether top, bottom, or side, and from any other boundary line, or corner, is feeble, or an improper situation for the subject or points of effect. The most feeble are those situations which are equidistant from the top and base lines ; or from the two sides.

"The central point is the most feeble of all, and, to a certain extent, they increase in strength or value as they diverge from the centre.

"But it is not every situation that may be at unequal distances from the boundary lines and corners, which is a strong point. The inequalities in distance must bear a mathematical ratio to each other, and one and two-thirds, two and three-fifths.

" Those points will be the strongest or best adapted for the reception of the subject, which are distant from the four boundary lines, and the four corners in degrees the most varied, yet bearing a mathematical ratio to each other, as one-third from the base, two-fifths from one side, three-sevenths from one corner, four ninths from another, and so on in every possible relation that it can bear between the opposite corners, the two upper corners, or the two lower, or the upper and lower, or the upper and lower of the same side, the two sides, or the top and base."

The latter part of this is rather abstruse and confusing, but there is something in it. The object is to avoid uniformity, and to get variety of composition. The late Norman Macbeth —an authority on art, who took an active interest in photography—in an excellent paper read before the Edinburgh Photographic Society, gave illustrations based on the above divisions, which will be in the recollection of the readers of the photographic journals, and I cannot do better than adopt his remarks on the divisions.

" After deciding on the breadth of picture—whatever it be—find the square of it. A diagonal line drawn from one corner to the other metes out the size of the length of picture. This proportion of breadth to the length suits almost every subject requiring either a vertical or a horizontal form. It so happens that the 'half-plate' size used in the camera is as near as possible of the relative proportions.

" Now, as diversity in unity is one of the essential elements in good composition, the method of producing this lies in certain subdivisions of the field being made both vertically and horizontally; every intersection or crossing of the lines constitutes points, which, if anything were constructed on them, would prove expressive.

" To divide the field into two equal parts both ways, the intersection would be in the centre; such a point, although

some might think it to be conspicuous, is nevertheless not expressive, inasmuch as it is too finely balanced on either side. To subdivide, again, the two sides would not produce good or expressive intersections, for it would tend to a too equal balancing of parts.

"Now, in order to find expressive parts of a field, in place of dividing it into equal numbers, such as two, four, six, or eight, divide it into unequal or odd numbers, such as three, five, or seven, and you produce points at each intersection which are easily composed, and always expressive.

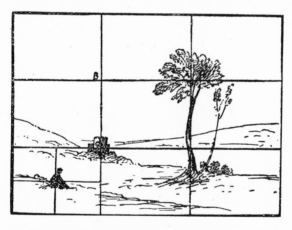

"Bear in mind that the centre of the field is the weakest point in it. To put an object there, especially in a landscape, divides the subject, and raises a conflict of interest on both sides; so much so, that if there be objects of interest on either side, the eye is tortured and distracted. In order to avoid this, and make important parts of a scene or figure expressive, I view them through a piece of glass—the half-plate size— divided into three parts each way, placing the intersections as much as possible over those parts in nature which are important. The same lines may be drawn on the focussing

glass when it is of the proportions I have described. This would enable the photographer to place the intersections on special parts of a scene—such as a ruin, a tree, a river, a boat, groups of cattle, figures, important parts of architecture, and interiors generally."

No two corresponding strong points should be used in the same picture. For instance, in the diagram, the strong point A is occupied by the tree, which forms a principal object; the corresponding point, B, must not be occupied by an object of the same weight, but C may be occupied by a principal object —in this case a ruin, which balances the tree. Further subdivision of the diagram would produce other strong points at the intersections, the position of the figure being found by the intersection of the bottom corner.

This method of division, for the purpose of finding the strong and weak points of a picture, becomes fanciful when carried out to its extreme limits; but if the broad principle is borne in mind, it will save the student from admitting formality into his composition, and help him to get variety.

CHAPTER XX.

IN the foregoing chapters I have endeavoured to show how pictorial photographs should be made, and how it is possible to carry out the laws of art even with the stubborn material that usually falls to the lot of the photographer. I have urged the student to learn the rules of composition, and light and shade, that they may help him to arrange his subject when arrangement is possible, and that he may be able to see and properly appreciate a good subject when one comes before him. Above all, I should like the student to attain to that sound knowledge which does so much towards checking that painful hesitation arising from not knowing what is good or what is the reverse, still so general with photographers.

There are many who think that if they devote much time and thought to the consideration of a subject, they will arrive at perfection, unheeding the fact that it is not the amount, but the quality, of the thought that will benefit the picture upon which it is bestowed.

Photography offers a wide range of subjects, and it is not easy to say what is impossible to the resources of the art ; but it is well to know, and to know at a glance, what to take or what to avoid. Some things are difficultly possible, but not worth doing. It is possible, for instance, to photograph a view by the aid of moonlight alone; but if we are to judge by pictorial results, it is not worth while. Yet, perhaps, nothing in nature is more lovely than moonlight. A rare

article is sometimes valuable because of its rarity; a certain etching by Rembrandt, without some shading on a tablecloth, is much more valuable than prints from the same plate in its more complete state; but it does not follow that we must admire a view any the more because the place from which it was taken was difficult of access, for difficulty does not create beauty. Sometimes the most admirable subjects occur at our own doors; but, being so near to us, we do not so easily see them. It is well, therefore, to know beauty when we see it, and the scope and limitations of the art by which we try to represent it.

Those who attempt impossible perfection generally end by achieving dulness. Now dulness is in art, as in many other things, the unpardonable sin. There was a time when the pompous perfection of Dr. Johnson's verse was read and admired; but a more reasonable world prefers something more natural and, perhaps, less perfect. In art it is better to do what is possible, or even easily possible, than to struggle after the unattainable, and fail. What the photographer has to do is to consider whether his subject is a good one; if he has done all for it in the way of placing figures, or cutting down obtruding branches, or other improvements of this kind (all of which should have been decided on or done beforehand), then he may expose the plate at once. Let him beware of delay or fidgetting, or over polish after he has decided that his subject is good enough. He must take care that his "good enough" is very good indeed, and if it is, he may be sure that any further attempt to improve it will damage it in some way. The attempt to "snatch a grace beyond the reach of art" always ends in failure. In landscape photography, there are some photographers, as I have just hinted, who are never satisfied, who fidget about, now this way, now that, and seem at a loss to arrive at any decision as to the point from which they shall make their effort. By this delay chances of

obtaining successful results are often lost. The wind may arise, the sun may become clouded; and if figures are introduced, the models tire. It is better to neglect unessentials than to lose the spirit of your picture.

Then there are other photographers, who care for nothing so much as the sharpness of focus shown in their negatives, forgetting that this optical quality is destructive of that natural look which all photographs should have—that open, daylight effect which is the aim of all real artists, whether painters or photographers—to get in their works. I am glad to see that the "pride of focus" is going out of fashion; excessive definition is not now looked upon as the chief glory of the photographer. I object as much as anybody to the sloppy-smudge order of photography, but when I see my way to getting a more atmospheric effect by sacrificing definition, that sacrifice is made without more ado. There are cases in which a picture may be exposed too quickly, quite apart from the question as to whether it was sufficiently exposed photographically. If a moving object is photographed in a shorter space of time than the eye takes to see it, the effect is ridiculous and against nature. Mr. Muybridge has effectually proved this in his curious instantaneous photographs of running horses and other animals, which are shown in positions that have never been seen by mortal eyes. In attempting to prove that artists are scientifically wrong, he has shown that they are artistically right. I think all artists will admit that there is more life and motion in a picture of waves that shows some slight sign that they were in motion than in the representation of a frozen sea. It has been well said, "If art consists in the accurate presentation of detail, then the highest art is the petrifaction of nature, and the wax-works of an anatomical museum are more artistically beautiful than all the marbles of Pheidias and Praxiteles." There is a higher truth than mere fact.

I have said above that it is better to neglect unessentials than to lose the spirit of your picture. There are other ways besides giving up the purely optical quality of focus, in which, by sacrifice, a picture may "suffer and grow strong." To illustrate this, I will, in conclusion, relate a little anecdote.

Some time ago, I walked into a painter's studio, and found the owner—a Royal Academician—at home, and at work. On the easel was a large and elaborately worked picture. The subject consisted of a group of young damsels sitting on the bank of a rivulet. In the foreground were masses of exquisitely finished foliage, flowers, and grasses. The occupation in which I found the painter engaged was that of deliberately obliterating portions of the delicately finished work which must have taken many days to elaborate. I asked him what he was about. His reply was one that I have always regarded as a lesson full of useful teaching : " I am trying how much I can do without." He had found that high finish in non essentials had detracted from simplicity, and simplicity is one of the most precious qualities to be found in art.

THE END

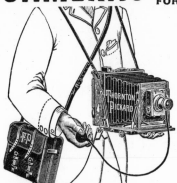

THE DICTIONARY
OF PHOTOGRAPHY,

FOR THE

Amateur & Professional Photographer.

By E. J. WALL, F.R.P.S.,

Revised, Corrected and Brought up to Date
By THOS. BOLAS, F.C.S., F.I.C.

Illustrated by many specially prepared Diagrams.

SEVENTH EDITION, ENLARGED TO 632 PAGES.

Crown 8vo, cloth, **7/6.**

London :

HAZELL, WATSON, & VINEY, LD., 1, CREED LANE, E.C.

THE LITERATURE OF PHOTOGRAPHY
AN ARNO PRESS COLLECTION

Anderson, A. J. **The Artistic Side of Photography in Theory and Practice.** London, 1910

Anderson, Paul L. **The Fine Art of Photography.** Philadelphia and London, 1919

Beck, Otto Walter. **Art Principles in Portrait Photography.** New York, 1907

Bingham, Robert J. **Photogenic Manipulation.** Part I, 9th edition; Part II, 5th edition. London, 1852

Bisbee, A. **The History and Practice of Daguerreotype.** Dayton, Ohio, 1853

Boord, W. Arthur, editor. **Sun Artists** (Original Series). Nos. I-VIII. London, 1891

Burbank, W. H. **Photographic Printing Methods.** 3rd edition. New York, 1891

Burgess, N. G. **The Photograph Manual.** 8th edition. New York, 1863

Coates, James. **Photographing the Invisible.** Chicago and London, 1911

The Collodion Process and the Ferrotype: Three Accounts, 1854-1872. New York, 1973

Croucher, J. H. and Gustave Le Gray. **Plain Directions for Obtaining Photographic Pictures.** Parts I, II, & III. Philadelphia, 1853

The Daguerreotype Process: Three Treatises, 1840-1849. New York, 1973

Delamotte, Philip H. **The Practice of Photography.** 2nd edition. London, 1855

Draper, John William. **Scientific Memoirs.** London, 1878

Emerson, Peter Henry. **Naturalistic Photography for Students of the Art.** 1st edition. London, 1889

*Emerson, Peter Henry. **Naturalistic Photography for Students of the Art.** 3rd edition. *Including* The Death of Naturalistic Photography, London, 1891. New York, 1899

Fenton, Roger. **Roger Fenton, Photographer of the Crimean War.** With an Essay on his Life and Work by Helmut and Alison Gernsheim. London, 1954

Fouque, Victor. **The Truth Concerning the Invention of Photography:** Nicéphore Niépce—His Life, Letters and Works. Translated by Edward Epstean from the original French edition, Paris, 1867. New York, 1935

Fraprie, Frank R. and Walter E. Woodbury. **Photographic Amusements Including Tricks and Unusual or Novel Effects Obtainable with the Camera.** 10th edition. Boston, 1931

Gillies, John Wallace. **Principles of Pictorial Photography.** New York, 1923

Gower, H. D., L. Stanley Jast, & W. W. Topley. **The Camera As Historian.** London, 1916

Guest, Antony. **Art and the Camera.** London, 1907

Harrison, W. Jerome. **A History of Photography Written As a Practical Guide and an Introduction to Its Latest Developments.** New York, 1887

Hartmann, Sadakichi (Sidney Allan). **Composition in Portraiture.** New York, 1909

Hartmann, Sadakichi (Sidney Allan). **Landscape and Figure Composition.** New York, 1910

Hepworth, T. C. **Evening Work for Amateur Photographers.** London, 1890

*Hicks, Wilson. **Words and Pictures.** New York, 1952

Hill, Levi L. and W. McCartey, Jr. **A Treatise on Daguerreotype.** Parts I, II, III, & IV. Lexington, N.Y., 1850

Humphrey, S. D. **American Hand Book of the Daguerreotype.** 5th edition. New York, 1858

Hunt, Robert. **A Manual of Photography.** 3rd edition. London, 1853

Hunt, Robert. **Researches on Light.** London, 1844

Jones, Bernard E., editor. **Cassell's Cyclopaedia of Photography.** London, 1911

Lerebours, N. P. **A Treatise on Photography.** London, 1843

Litchfield, R. B. **Tom Wedgwood, The First Photographer.** London, 1903

Maclean, Hector. **Photography for Artists.** London, 1896

Martin, Paul. **Victorian Snapshots.** London, 1939

Mortensen, William. **Monsters and Madonnas.** San Francisco, 1936

*Nonsilver Printing Processes: Four Selections, 1886-1927. New York, 1973

Ourdan, J. P. **The Art of Retouching by Burrows & Colton.** Revised by the author. 1st American edition. New York, 1880

Potonniée, Georges. **The History of the Discovery of Photography.** New York, 1936

Price, [William] Lake. **A Manual of Photographic Manipulation.** 2nd edition. London, 1868

Pritchard, H. Baden. **About Photography and Photographers.** New York, 1883

Pritchard, H. Baden. **The Photographic Studios of Europe.** London, 1882

Robinson, H[enry] P[each] and Capt. [W. de W.] Abney. **The Art and Practice of Silver Printing.** The American edition. New York, 1881

Robinson, H[enry] P[each]. **The Elements of a Pictorial Photograph.** Bradford, 1898

Robinson, H[enry] P[each]. **Letters on Landscape Photography.** New York, 1888

Robinson, H[enry] P[each]. **Picture-Making by Photography.** 5th edition. London, 1897

Robinson, H[enry] P[each]. **The Studio, and What to Do in It.** London, 1891

Rodgers, H. J. **Twenty-three Years under a Sky-light,** or Life and Experiences of a Photographer. Hartford, Conn., 1872

Roh, Franz and Jan Tschichold, editors. **Foto-auge, Oeil et Photo, Photo-eye.** 76 Photos of the Period. Stuttgart, Ger., 1929

Ryder, James F. **Voigtländer and I:** In Pursuit of Shadow Catching. Cleveland, 1902

Society for Promoting Christian Knowledge. **The Wonders of Light and Shadow.** London, 1851

Sparling, W. **Theory and Practice of the Photographic Art.** London, 1856

Tissandier, Gaston. **A History and Handbook of Photography.** Edited by J. Thomson. 2nd edition. London, 1878

University of Pennsylvania. **Animal Locomotion. The Muybridge Work at the University of Pennsylvania.** Philadelphia, 1888

Vitray, Laura, John Mills, Jr., and Roscoe Ellard. **Pictorial Journalism.** New York and London, 1939

Vogel, Hermann. **The Chemistry of Light and Photography.** New York, 1875

Wall, A. H. **Artistic Landscape Photography.** London, [1896]

Wall, Alfred H. **A Manual of Artistic Colouring, As Applied to Photographs.** London, 1861

Werge, John. **The Evolution of Photography.** London, 1890

Wilson, Edward L. **The American Carbon Manual.** New York, 1868

Wilson, Edward L. **Wilson's Photographics.** New York, 1881

All of the books in the collection are clothbound. An asterisk indicates that the book is also available paperbound.